Books are to be returned on or bef
the last date below.

Glamorgan Centre for
Art & Design Technology

Glyntaff Rd, Glyntaff,
Pontypridd CF37 4AT

HDi
HARPER
DESIGN
international

An Imprint of HarperCollins*Publishers*

HOW TO CREATE VIRTUAL BEAUTIES

DIGITAL MANGA CHARACTERS

Copyright © 2004 by Agosto

First published in English throughout the World, excluding Japan, in 2004 by
Harper Design International
An imprint of HarperCollins*Publishers*
10 East 53rd Street
New York, NY 10022
www.harpercollins.com

This book was first published in Japan
in 1999 and 2000 by
Agosto, Inc.
5316 Laurel Canyon Blvd., N. Hollywood, CA 91607
www.agosto.com

HarperCollins books may be purchased for educational, business, or sales promotional use. For information, please write: Special Markets Department, HarperCollins*Publishers* Inc., 10 East 53rd Street, New York, NY 10022.

Printed in Paraguay by AGZ (www.agz.com.py)

First printing, 2004

Library of Congress Control Number: 2004101298

ISBN 0-06-056771-6

contents

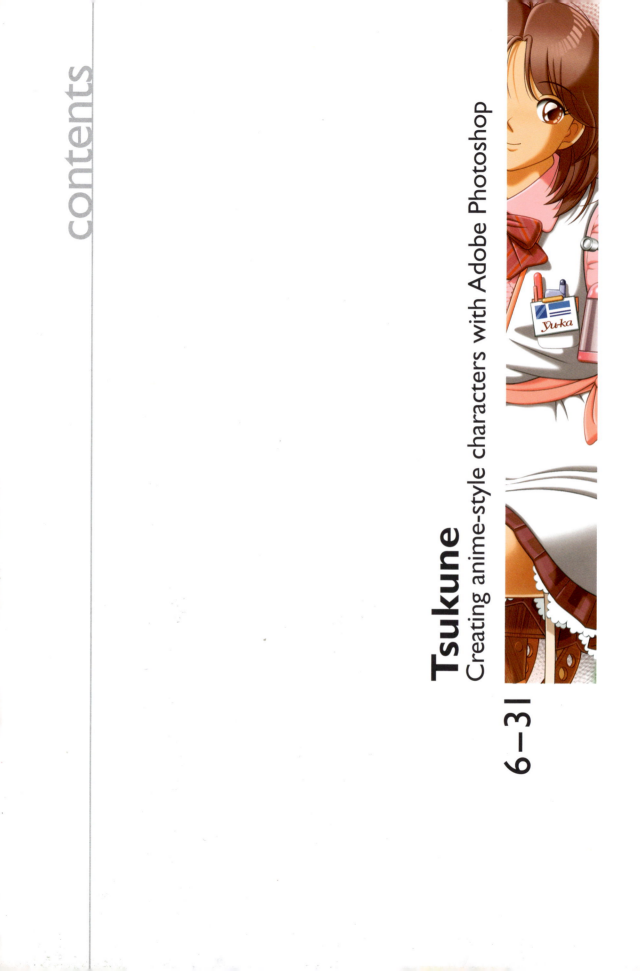

Yukie Matsuo
Rendering 3D characters from 2D forms

Nekotom
Bringing your anime characters to life

Watanabe, Tetsuya
Creating virtual beauties with the latest technology from LightWave 3D

Tsukune

Creating anime-style characters with Adobe Photoshop

The first part of the work was done mainly with Illustrator and the second part was done mainly with Photoshop. In terms of time and importance, 80% of the total work was done with Illustrator. I try not to cut corners in this part of the process, because the quality of the work at this stage greatly determines the difficulty and flexibility of the work with Photoshop later. Illustrator was used to define all of the shapes and areas of an illustration while Photoshop was used to apply colors and composite images.

Tsukune

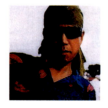

Profile

I was born in Shimizu, Shizuoka prefecture. In 1984, I began working as a freelancer providing illustrations for magazines and advertising. Since the jolting discovery of Adobe Illustrator in 1990, I slowly shifted to using a Macintosh computer. What happens when someone who can't even operate an ATM machine tries to use a Macintosh? The grand experiment continues. (Laugh)

Working Environment
- PowerMacintosh 8100/100AV (147M) KT-7.5.3
- Macintosh IIci (32M) KT-7.5.3
- Epson GT-6000
- Sony RMO-S350
- Illustrator 5.5J
- Photoshop 2.0, 3.0.3J, 4.0J
- Painter 4.0.1J

QYC01713@nifty.ne.jp
http://member.nifty.ne.jp/tsukune/

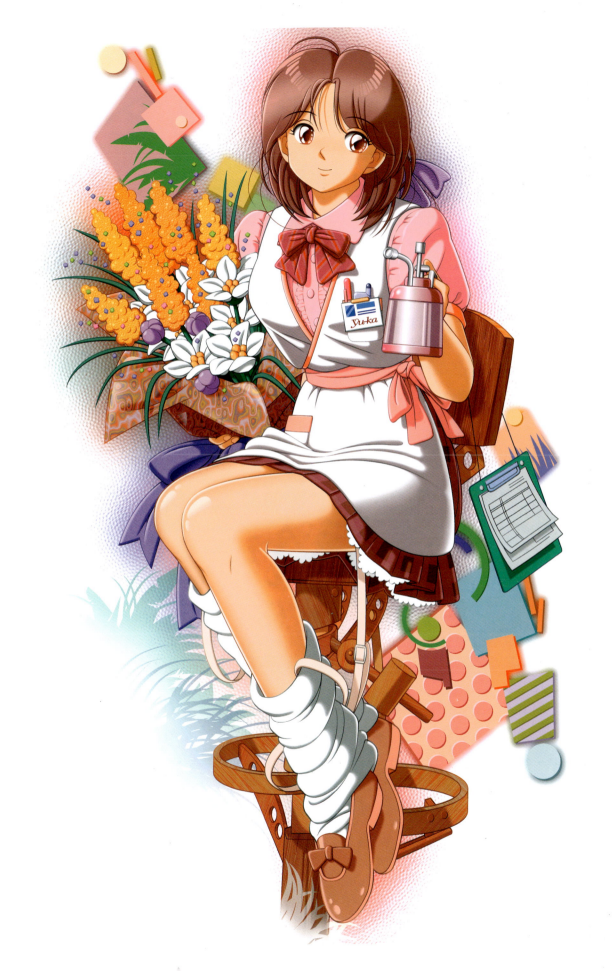

Girls with modest personalities

In the beginning, when I was a novice Illustrator user, I created beautiful girls so that I could practice using the Pen tool—I figured I would last longer if I was creating something I liked. I have now mastered Bezier Curves, but I'm still creating these beautiful girls.

I get fewer jobs now with the collapse of the bubble economy, but I am creating more beautiful girls than before. I say that I'm trying to sharpen my skills, but I wonder if people believe it. (Laugh)

Although I don't have any special interest in beautiful females, I tend to create plain characters who don't have strong personalities—what people call typical anime-style characters, characters without backgrounds or stories behind them, those who don't even show their girlish personalities. This might sound a bit eerie. However, I believe too much individuality in these characters deters audiences from creating their own image of these girls. So, when I'm making these characters, I feel it's better to minimize their individualities.

I would like to continue creating illustrations that audiences can project their images onto, while at the same time keeping that ambiguity.

Beginning with Illustrator

My method of making illustrations doesn't involve any difficult or sophisticated computer graphics and techniques. In fact, the way I work is based on an accumulation of such low-tech methods that I can't even believe myself. All I need is Adobe Illustrator, Adobe Photoshop and Corel Painter. I don't use a tablet or any other special devices. Also, my method hardly begins to touch the amount of memory the Macintosh has. I guarantee that this method will work—even with the weakest hardware set up. However, you do need some patience.

The first part of the work was done mainly with Illustrator and the second part was done mainly with Photoshop. In terms of time and importance, 80% of the total work was done with Illustrator. I try not to cut corners in this part of the process because the quality of the work at this stage greatly determines the difficulty and flexibility of the work with Photoshop later. Illustrator was used to define all of the shapes and areas of an illustration while Photoshop was used to apply colors and composite images. Clearly defining which software is used for which tasks makes workflow management easier.

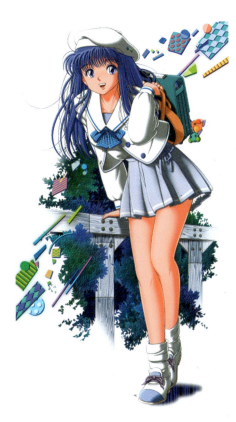

Preparing the draft sketch

The first step is making the draft sketch that will be used in Illustrator (01). I usually sketch quickly using a 2B pencil on low-quality paper—as ideas are always flowing in my head. At this stage I pay attention to not breaking my train of thought, and I don't worry about overall composition, small details or little inaccuracies. By the way, this draft sketch was fairly clean compared to other ones.

I scanned the sketch as a grayscale image at 144 dpi, then I used Photoshop to convert it into a black-and-white image at 72 dpi, while keeping the image size the same, and saved it as a PICT file. This became my reference image.

Later, when I was drawing the keylines, the main lines of my character, I tried not to merely trace the lines of the sketch. It is important to think of the draft sketch as just reference information, and draw new lines using your eyes and brain.

Even though you can see details, using an EPS image as a draft sketch is out of the question when you're working in

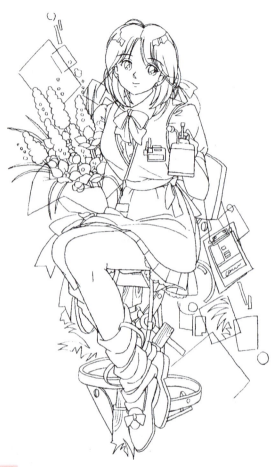

01 This draft sketch was cleaner than usual. The background was still vague. How were the character and other elements going to develop?

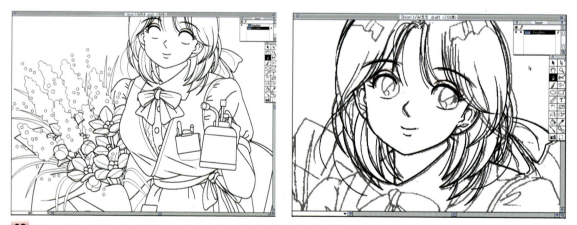

02 I began drawing with the Pen tool. After spending a long time laying down Bezier lines like this, I could feel my mind becoming empty. This work might have the same effect as Zen meditation.

Illustrator. A jagged black-and-white image is all you need for a draft sketch.

Drawing the keylines

Using the draft sketch as reference, I drew the keylines of the character with the Pen tool (02). Because the shapes I drew at this stage would be the basis for the areas to be painted and various masks, I made them with great care. This minimized the need for troublesome corrections later. Basically, I drew lines (and some filled shapes) of 5 or 6 different sizes. In certain instances, because a simple Bezier line looked hard, I added filled shapes at both ends and treated them as one line (03).

Since I didn't use this technique very much when I made Shiori, please see Marina as an example of this technique (04, 05).

Next I created a new layer and copied the drawn lines onto this layer. While copying these lines, I used Join and Cut to create the areas to be painted. The lines were left as simple paths (06).

03 In order to simulate pen pressure, I added a sharp, pointed object at the end of a Bezier line.

04 An Outline view of Marina, showing the Bezier lines in use.

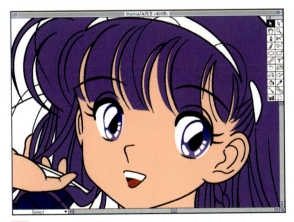

05 A Preview look of Marina.

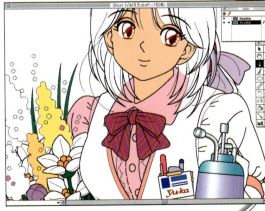

06 The colors I used to fill in the shapes here were rough and so I adjusted them later in Photoshop.

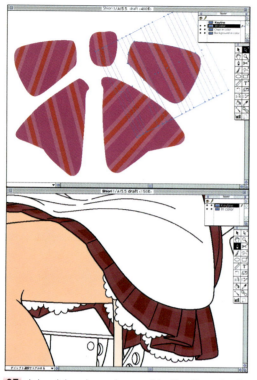

07 I changed the angle on each pattern of the skirt with a mask-applied ribbon pattern instead of using a 2D flat texture. Exerting a little more effort on the details created a more realistic look, tighter impressions and better overall results.

In some cases I found it quicker to use the Outline view of the keylines as a draft and trace over it with the Pen tool. Both methods create almost the same results. In any case, while it required a little additional effort, keeping the keylines and the areas to be painted on two different layers allowed more flexible adjustments of individual items later in Photoshop, resulting in a much higher-quality end product (07).

Drawing the background

I drew the chair the girl is sitting on and the geometric shapes behind her on separate layers (08). Sometimes, when the background of an illustration requires more depth and more objects, the number of background layers gets so big that it looks like mille-feuille. I like to avoid this. It's not always good to put a lot of details in a drawing.

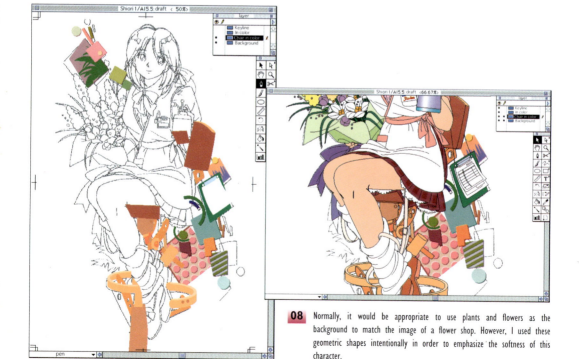

08 Normally, it would be appropriate to use plants and flowers as the background to match the image of a flower shop. However, I used these geometric shapes intentionally in order to emphasize the softness of this character.

Creating the mask images

Creating the basis for the mask images allows you to select each and every area of the illustration when you're working in Photoshop.

The mask images were made in grayscale—with the areas to be selected filled in white, and the areas to be protected by the mask filled in black. The masks for each of the areas—such as hair, any exposed skin, clothes, flowers and other items where shadows and highlights might have been added with Photoshop— were created on separate layers.

This work is relatively simple. I just copied the items that I needed for each mask from the objects I already created for coloring onto a new layer. Then I filled the areas where I wanted to make selections in white and filled the areas that I wanted to mask in black (09). At this stage I made sure to add registration marks for trimming—as these would be needed to open each layer in Photoshop.

The last step in Illustrator was to separate the multiple layers and save each layer as an individual file (10). I did this by selecting the layer I wanted to save and deleting all other layers from the Layers palette. Then I saved the remaining layer with an appropriate name.

I undid all the steps until all the original layers were back. Then I deleted the just-saved layer from the Layers palette. I repeated this process until the last layer, which I saved as an individual file. This is very boring work, but don't fall asleep. I hope to automate this step in the future. (Laugh)

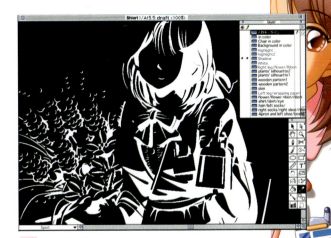

09 The white areas of this mask image became shadows once I started working in Photoshop.

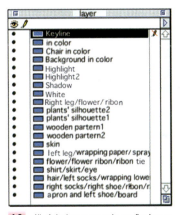

10 All of the layers except the top five became mask images. As indicated by the names of these layers, some contained the mask for more than one item. However, because these items were relatively spaced apart it was easy enough to use them individually.

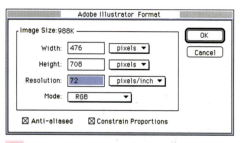

11 Opening an Illustrator file with Photoshop.

12 Here are some of the mask images before I softened them.

Creating details with Photoshop

First I opened all the Illustrator files with Photoshop. I made sure that the image size was that of the final image—in this case 476 pixels wide by 708 pixels high at 72 dpi. The images for coloring were in RGB mode, and the mask images were in grayscale mode (11, 12).

Next I opened the mask image layers that I made to create shadows. Of course, they could have been used as they were, but in order to soften the shadows, I used the Airbrush and Toning tools to add gradations on some of the borders between the black and white areas (13, 14, 15, 16, 17).

Once I made the appropriate adjustments to all of the images, I saved the mask images as grayscale PICT files.

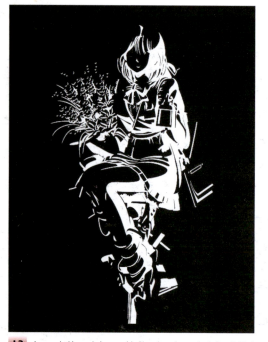

13 I opened this mask image with Photoshop. It was basically all black and white and contains no halftones.

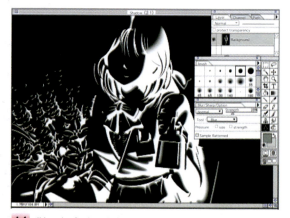

14 Using the Brush tool, I gave softness to the mask image with some gradations. This helped create more subtle shadows.

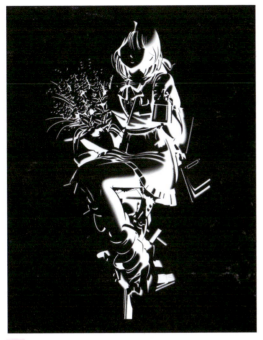

15 This is the mask image after I retouched it.

16 I used this mask image to create highlights. I added some gradations here, too.

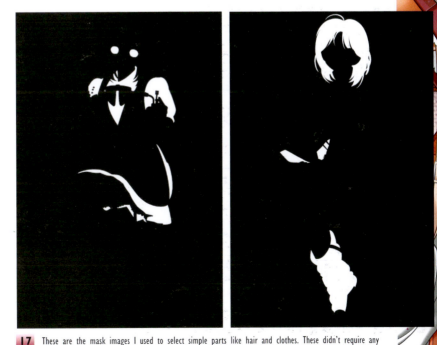

17 These are the mask images I used to select simple parts like hair and clothes. These didn't require any additional gradations.

Creating shadows and highlights

At this point I integrated each colored image that I opened with Photoshop into one file by drag and drop. This file initially consisted of 5 layers. When working with Illustrator I never create a layer for hair. Instead, I use a previously saved mask image to select the entire hair area. Then I fill the selection in brown and load this information onto a new layer.

When it's inconvenient to apply the same amount of adjustment at once on several areas or when I need to repeatedly apply an adjustment to just one area, I work on independent layers—since there is less chance that I will make a mistake. If you want to save memory and time, merge the layer you just worked on with the layer immediately below.

In Illustrator all colors are in CMYK mode. So when images are opened with Photoshop the colors look dull on the monitor. The first thing I do is adjust the saturation of all of the colored areas a little. This step isn't absolutely necessary at this stage, but I feel that I can enjoy the following steps better if I do it (18). I guess this is similar to how some people prefer to start drawing the eyes when creating an illustration.

Next I opened the mask image that I made to create the shadows and loaded the selection on the colored surface layer (19). Using the Curves and Hue/Saturation

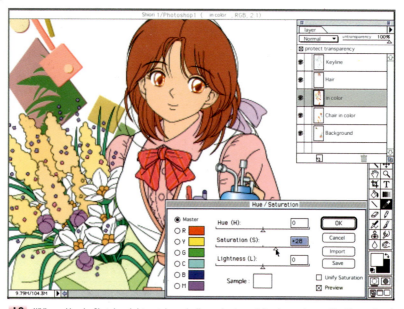

18 While working in Photoshop I integrated my keyline and other coloring images in one file. Then, using the Hue/Saturation function, I increased the saturation for each layer a little.

functions I adjusted the brightness and color saturation of the shaded areas (20).

While I'm doing this type of retouching, I paint directly onto the selected areas with the Airbrush tool to give some variations in shadows—on a new layer, to be safe—but I try not to overdo it.

19 Load Selection is probably the dialogue box that I use most frequently when I'm working in Photoshop.

20 Adding simple shadows like this makes the character stand out much more. The mask image that I used to create these shadows is shown at the bottom right of the screen.

Adding variations to the hair color

First I selected the hair layer on the Layer palette and locked the Protect Transparency box. Using the Eyedropper tool I sampled the color of the hair and then lightly applied color using the Airbrush tool (21).

At this point my application was moderate. Later on I added shadows by loading the selections for shadows in the hair. I also added highlights by loading the selections for highlights and adjusting the Curves and Hue/Saturation functions to lighten up the highlight areas (22).

Often I have to repeat this process of loading the selection and adjusting for the other shaded areas. Previously saved mask images become very handy in these

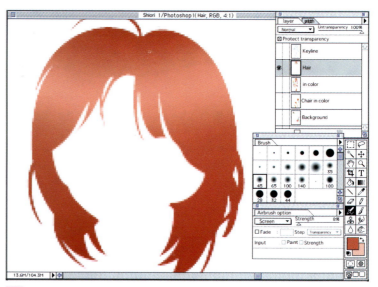

21 This is the layer I used to color the surface of the hair. The Airbrush tool helped it from being too heavy.

22 I added highlights to the hair by using the Curves and Hue/Saturation functions. It is important to balance the brightness and saturation levels.

instances. Although opening mask images every time may be a little tiresome, it is much more accurate to use selections made this way than using the Magic Wand tool or Path. So I prefer this method.

Adding wood grain details

To add wood grain to the chair that the girl is sitting on, I opened one of the several mask images to select the surfaces of the chair and prepared a mask image for the wood grain (23, 24). Then I loaded the common areas between these two mask images onto the chair coloring surface layer and adjusted the brightness using the Curves function. Since I wanted to avoid having the adjoining parts appear flat, I changed the angle of the wood grain pattern a little from one part to another (25). In some cases, I used an inverted grayscale version of the wood grain pattern.

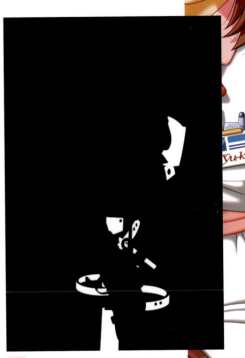

23 This is the mask image I used to select one side of the chair. The mask image for the other side of the chair was a separate file.

24 This is the mask image of the wood grain texture. To create this pattern I stretched a texture made with a filter from KPT, a must-have plug-in for Photoshop.

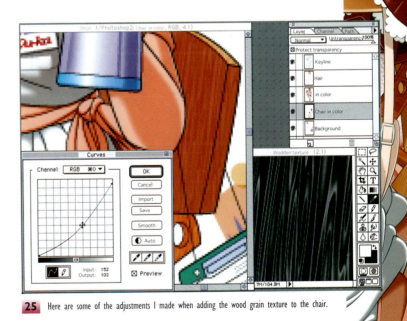

25 Here are some of the adjustments I made when adding the wood grain texture to the chair.

Giving texture to the bouquet

I used the Noise f/x filter of the plug-in KPT to give a silky texture on the ribbon around the flower bouquet. It was an easy way out (26).

After adding a pattern to the wrapping paper of the bouquet, I decided to color it completely. So I created a texture with the KPT Texture Explorer filter to fill the wrapping paper. Then I adjusted the colors and brightness to blend them with the surroundings (27, 28).

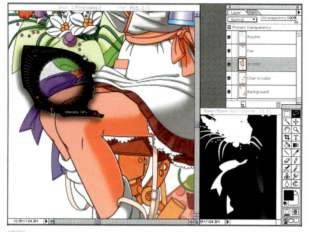

26 When using the Load Selection function, it is easy to accidentally load all of the selections. Unwanted selections can be unselected by pressing the command key and the Lasso tool.

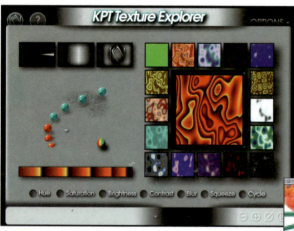

27 I used the Texture Explorer filter on the KPT plug-in to give texture to the wrapping paper.

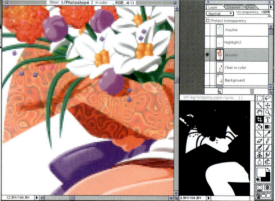

28 I only used this kind of effect in special cases.

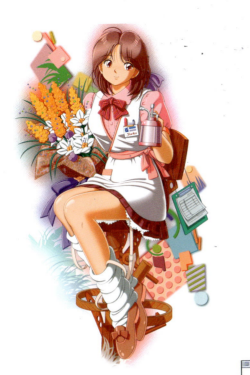

33 This is what my character looked like after I added the blurred background layer.

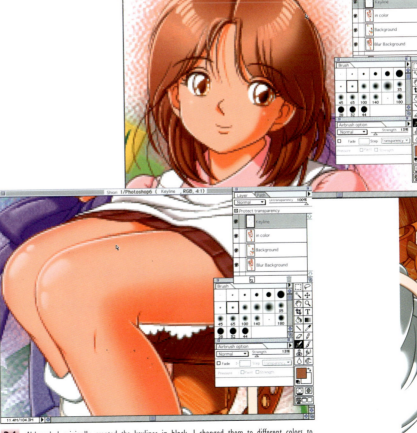

34 Although I originally created the keylines in black, I changed them to different colors to match the surrounding areas.

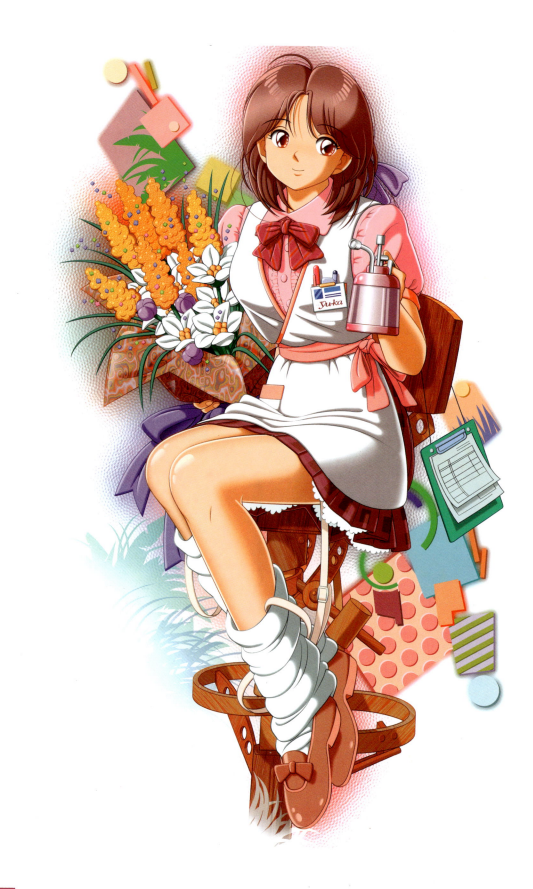

Welcome to Macintosh♥

A Happy New Year '99

Difficulty: ★ ★

Software: HexaSuper, LightWave 3D, Photoshop

Yukie Matsuo

Rendering 3D characters from 2D forms

Enjoying the rendered images of a model is no different from enjoying a beautiful 2D computer-generated girl. However, with 3D animation, since we have added an extra dimension to a 2D character, there should also be an additional dimension to enjoying the character. Changing the pose of a real figurine is not easy but you can make a digital figure pose any way you want, as long as it's modeled correctly. You can even change colors and make other modifications easily.

Yukie Matsuo

Profile
I was born in 1975 and now reside in Tokyo. I graduated from the Economics Department at Keio University. I discovered the fun of 3D computer graphics while at the university. Then I got a job at a videogame production company. At 29 years old, I'm dreaming about a world where I can play with beautiful 3D computer-generated girls as much as I want.

Working Environment
- Pentium233 (128M)
- LavieNXLW23D/5 (NEC)
- HexaSuper (Rokkakudaio)
- LightWave 3D
- Photoshop

yukim@tke.att.ne.jp
www.geocities.co.jp/Hollywood-Kouen/3781

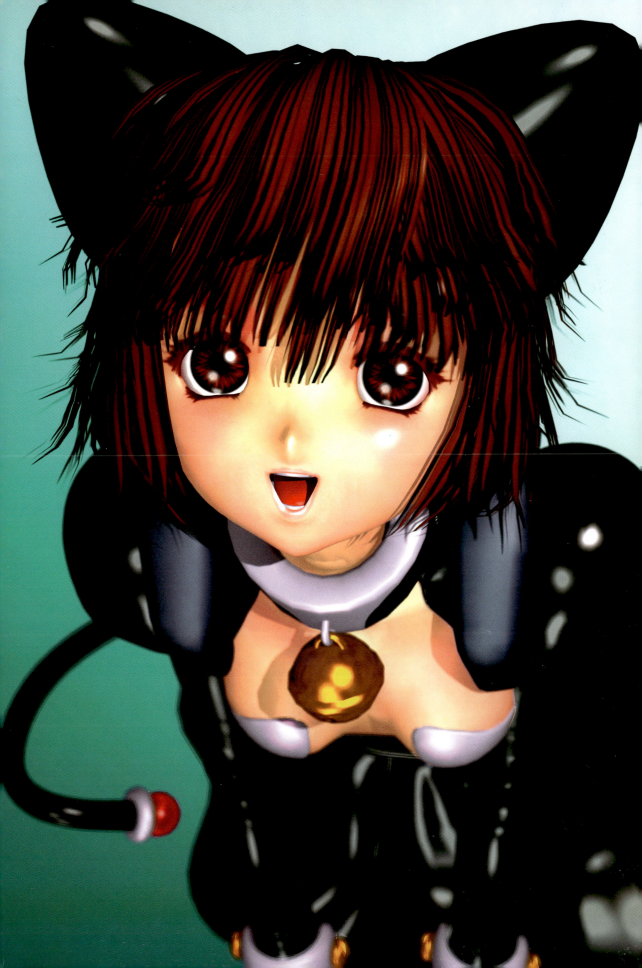

The pleasure of doing something naughty

Three years ago most of the female characters that were created in 3D were rather realistic, and not many of them I could consider to be "cute." In fact, I found them rather scary. That's when I began wondering if there was a way to make beautiful 3D girls that were less real and more like those in 2D anime—so that they wouldn't look so scary.

The first thing that popped in my mind was figurines of beautiful girls. So, I got hold of the 3D software called HexaSuper* and began making 3D characters that resembled those figurines. Two years have passed. Finally, I think that I am beginning to see what I really want to make.

I've concluded that I don't want to create figures in 3D, but rather I want to express the cuteness of 2D computer-generated characters using 3D models. And since I'm creating on a PC, I would like to show those details that are not possible to express with real life figurines, such as the hair and delicate colors.

Although I use anime-style features, the beautiful 3D girls I try to create are actually more in the style of 2D illustrations rather than 2D anime.

Anime characters are painted on cells that have a limited range of colors and I don't think this is suitable for creating beautiful girls. This is why I use the plug-in Raytracing rather than Celshader when rendering in LightWave 3D. I have been struggling to create a model that is so 2D in style that people won't believe that she is a 3D model. But I still haven't succeeded.

Making beautiful anime-style girls in 3D

Since the theme of this book is how to make beautiful girls, I will provide some tips for creating beautiful anime-style girls. These tips aren't actual method for making them, but are my own ideas about how to make them look as cute as 3D characters. Everyone has different ideas of what they consider to be cute, so I will give pointers for converting what you think is a cute 2D character into 3D. Since the tools themselves aren't very important, you can use this as a reference if you want to make beautiful anime-style girls.

The proportions of anime characters' bodies are fairly close to those of actual humans. Some have large

* HexaSuper: http://www.shusaku.co.jp/hexa/

breasts and some have small breasts. However, there are some differences in the balance of the parts, such as their limbs are longer and the hip is positioned higher. In addition, their faces are often altered quite a lot. So, I will give you tips for creating their faces.

Rendering a beautiful girl

Even a beautifully built model will come out horribly if the lighting and the camera angle are wrong. In other words, even a not-so-well-built model (one that may look cute only from a certain angle) could be rendered to look really cute if all you need is a still image. All you need to do is render the model at that certain angle. You may say that this defeats the purpose of creating a 3D character. But even in real life girls study their faces to find out the angles that make them look better. So, it's all right. (I know it's a poor excuse.) Adjust the lighting to avoid strong shadows and add reflections of the lights in the eyes of the model to make her look cute.

Enjoying a beautiful computer-generated 3D girl

Turning a beautiful girl around and around to look at her from different angles when I'm working on her makes me feel like I'm actually controlling a beautiful girl at my will. It makes me feel

a little weird. (Am I a pervert?) I get chills spinning her head. And spinning the model before dressing her is even more exciting.

Modeling a beautiful girl is fun in itself. But when I make the model strike different poses for rendering and look at her from different angles I get the sensation of doing something naughty. Making beautiful girls is such delightful work. Isn't this the proper way to enjoy a beautiful computer-generated 3D girl?

Enjoying the rendered images of a model is no different from enjoying a beautiful 2D computer-generated girl. However, with 3D animation, since we have added an extra dimension to a 2D character, there should also be an additional dimension to enjoying the character. 3D artists don't usually released original modeling data—maybe because they are afraid that their data will be copied and altered. However, I would definitely want you to enjoy these characters the way I do.

Changing the poses of a real figurine is not easy but you can make a digital figure pose any way you want, as long as it's modeled correctly. You can even change colors and make other modifications easily. You can render her as much as you want.

Studying the details of an anime-style character's face

Balance: Human eyes are fairly small, and they are more closely spaced than people realize. By comparison, the eyes on an anime-style face are spaced more apart, and they are really big. Also, the gap between the nose and the mouth is small. And sometimes, the chin is longer. In general, the nose is tall, and the mouth and chin stick out more than the eyes.

Outline: An anime-style face is wider than a human face and has a skinnier chin. The cheek line of a real human face peaks at the cheekbone. However, on an anime-style face the cheek line peaks at a point a little lower, almost at the same level as the bottom of the nose.

Nose: It should be small. There are no wings on the nose of an anime-style face—though it could have nostrils. The base of the wings of the nose on a human face is indented. However, because the anime-style face has no wings on the nose, it is smoothly connected onto the cheeks. The tip of the nose is pointy. The column of the nose on a human face starts between the eyebrows and the area between the eyes is indented. However, looking at beautiful 2D anime-style girls, the column of the nose often begins right below the eye level. Also, the line that connects the column of the nose and the inner corner on the eye is indented on a human. However, it is better to express this line with a smooth arc when making an anime-style face. In order to show this, use a slight arc between the eyes and make a sharp bridge of the nose starting a little below eye level. It should be really sharp.

Lower eyelids: Because human eyeballs are wrapped in eyelids, there are indents between the lower eyelids and the cheeks. Re-creating these indents on an anime-style character doesn't look right. In fact, they look cuter without these indents.

Eyes: Often the eyes on an anime-style character are painted far back from the nose and the corners of the eyes extend almost to the side of the face. However, trying to do the same thing on a 3D character will cause the eyeballs to stick out of the face. The corners of the eyes on the profile of a human face look extended, but this is because they extend towards the sides of the face looking from the front to contain eyeballs. Also, the eyelids cover the eyeballs, making the corners look extended. If you look carefully at figurines, the eyes are integrated into the face, creating curved surfaces that are incapable of holding eyeballs. In fact, in some cases the eyes are positioned looking outward when viewed from above.

If you don't need eyeballs, you can simply paste polygons for the eyes onto the face and add textures to look like a figurine. However, what should you do if you want to add eyeballs? This is quite a difficult problem. If you have some time, try studying eyelids and eyeballs. My tips to solve the problem of the eyeballs sticking out are: don't extend the corners of the eyes too far back to the side of the face, make the pupil of the eyes large, elongate the eyeballs vertically (though, this prevents the eyeballs from turning vertically). Also, with these characters the eyes are made larger than life. However, because this includes the eyelashes, you have to make your eyes with this in mind. This is a point where people often make a mistake.

Mouth: It should be small. How could she eat anything with it? It should also be pretty flat. In anime the upper lip is often eliminated altogether. However, 3D models are sexier if the lips are realistic. Also, human lips stick out quite a bit. However, an anime-style mouth is made by splitting the surface between the nose and the chin. So, don't make the lips stick out too much.

Turning a beautiful 2D girl into 3D using HexaSuper

A ReadyMaid is a beautiful girl OS for the next generation of PCs. Naturally, she has voice-recognition capabilities. She downloads e-mails, empties trashcans, searches files, plays games with you and destroys viruses. In other words, she is a maid who resides on your PC. Every PC will come with one, and you will be able to create your own maid by downloading the data for her face, body, character, clothes and all other elements from the Internet.

Because one's ReadyMaid divulges a lot about that person, it could be quite embarrassing if someone sees your ReadyMaid. This particular one is wearing a cat costume to suite my tastes (01). She is a prototype in development, and is supposed to become the basis for a future mass-production model. I'll give you tips so that you can create your own beautiful girl for your PC.

First, you have to draw a picture, as a blueprint, of what kind of beautiful girl you want. A front view is sufficient but it's even better if you draw a profile view as well. If you are not used to modeling, you could get completely lost without first drawing these images. So, it's a good idea to do this.

Draw just the face if that's what you're going to model. Draw the entire body if that's what you're going to model. How the face looks, what sort of figure she has

and the clothes she wears are all very important. Also, you should decide on how to break up the figure into separate parts while you're drawing these images.

Making the head

Once the blueprint is done I begin by modeling the face. I use HexaSuper to make the general outline of the head, and then use LightWave 3D for the details. HexaSuper automatically creates a symmetrical model, which makes my work a lot easier.

I brought up the frontal image of the face onto the background to use it as template. Then I drew the lines for the eyes, eyebrows and mouth. I used just one point for each corner of the eyes, and used equal numbers of points for the upper and lower eyelids. There should be as few points as possible (02). However, when I turned it around, I could see that something was wrong (03).

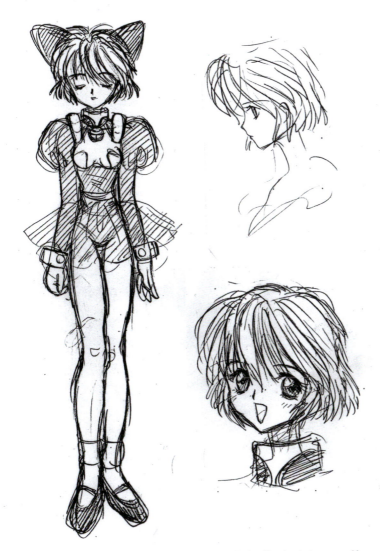

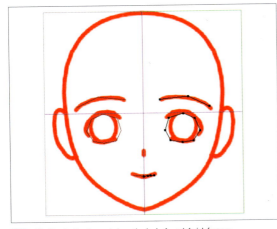

02 Working in HexaSuper, I drew the basic frontal facial features.

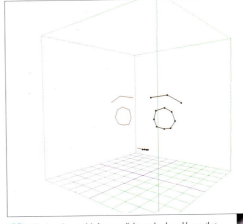

03 Viewing the model from a slight angle, I could see that something was wrong.

When you draw points from the front view using HexaSuper, the program places them at 0 depth. Therefore, everything you draw frontally will be on a flat plain. In order to give your model depth you must work from the side view.

To fix this problem I brought up the profile image of the face as a template and used it to position the eyes, eyebrows and mouth. Then I drew the line for the nose (04).

This time when I turned it around it began to look more like a face. But I still needed to do more work (05).

When the model is viewed from the top her eyes and mouth should be arched. At this point they were straight, so I needed to curve them (06). When I was doing this, I was careful not to move the points sideways, because this would have altered their shapes in the front view. I also adjusted the balance of the face at this stage.

Next I went back to the front view of the template and drew the outline of the face (07). Then I drew the line along the jaw using the profile template (08). It looked like this from an angle (09).

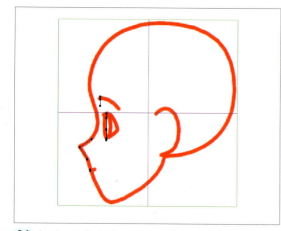

04 I used my profile sketch as a template and drew the basic features.

05 So when I turned the model to the side she began to have some depth.

06 When I viewed the model from the top her eyes and mouth were straight, so I adjusted them.

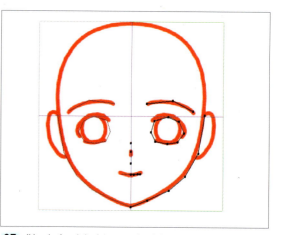

07 Using the frontal sketch as a template, I drew the outline of the face.

Next I drew the cheek lines. In the front view I drew a new line from one of the points of the eye following the outline of the face (10). In the side view I pulled the cheek section of the line that I had just drawn and adjusted it using the diagonal view. Then I adjusted the jaw section of the line using the profile template. The important thing here is for the point below the nose to be at the most forward position (11). It looked like this from an angle (12).

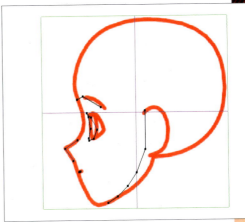

08 Using the profile template, I drew the jaw line.

09 The jaw lines were beginning to define her face.

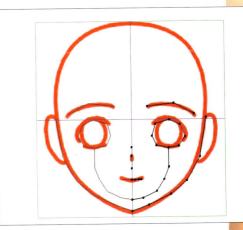

10 Next I added the definition of her cheeks.

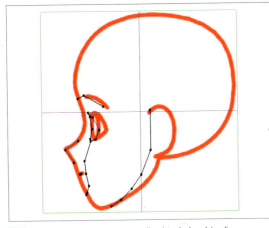

11 In the profile view I was able to adjust her cheek and jaw lines.

12 With both the cheek and jaw lines in place her features were starting to emerge.

At this point I could almost see her face start to emerge. About 80% of the work was done. All I needed to do now was add lines to apply the polygons. You can make a cute face if you repeatedly adjust the balance of the face until you get something you like at this stage.

Next I used the template that I had made earlier to draw the profile outline of the character's face (13). I connected the two eyebrows, the nose through the center point, and the mouth to the jaw line. I also added lines to make the cheeks pointy.

Defining the cheek lines

To give my character some definition I added a new cheek line in between the jaw line and the cheek line I had drawn earlier. I connected this new cheek line to the eyebrow. The cheek line that I drew earlier formed the outline seen from a sharp angle, and this new line formed the outline when seen from a less sharp angle. Keeping this in mind, I adjusted them to get the effect I wanted when looking from various different angles. I have shown the front view (14), the side view (15), and the diagonal view (16) for reference.

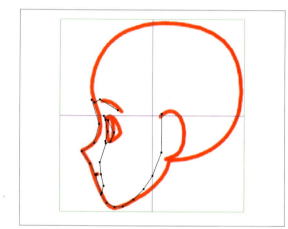

13 Using the template again, I connected some of her facial features, including the eyebrows.

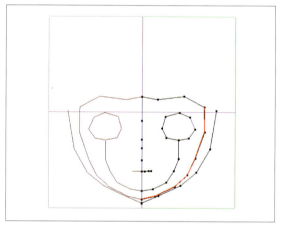

14 I added a second cheek line (which connects to the eyebrow) to give my character some definition.

15 Here is the new cheek line seen in profile.

16 And here is the new cheek line seen from an angle.

Next I drew a line from the cheek to the nose. This line could be said to be the biggest difference between a real human face and an anime-style face. A human nose has wings and is indented. However, an anime-style nose has no wings and rarely has nostrils. Looking at the face of a figurine of a beautiful girl shows that her cheeks and the tip of her nose is connected by a smooth line.

So, I connected the tip of the nose to the cheekbone (17). Then I made it into a curve by adding two points between the nose and the first cheek line (18). The cross section of the figure looked like this at this point (19).

Now, most of the important lines were done. So, I began adding polygons by connecting all of the lines (20).

17 I connected the nose to both the first and the second cheek lines.

18 Then I added two points between the nose and the first cheek line.

19 Here is the model as viewed from the top.

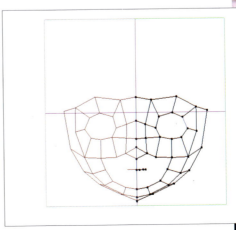

20 I began adding polygons to her face.

Making the lips

When I began, the mouth was just a straight line connecting 4 points. First, I erased the lines that connected the nose to the jaw, and then I added points to make it a ring (21). Next I selected the mouth line and extended it (22). Then I further extended the ring to form the lips (23). The lips were fairly flat.

I connected the lips to the face and added more polygons to the face. Then I added points in the areas that didn't have enough points. The red points are the ones that I added (24).

I displayed all the polygons. Doesn't this look pretty good (25)?

The way to add polygons around the eyes and the mouth is in concentric rings. Although, it's an anime-style character, I keep the flow of the facial muscles in mind.

Inserting the eyeballs

The lazy way to make an eye is to place a polygon so that it covers the eye socket. However, to do it the right way first make the eyeball. I made a sphere, and fit it onto the face. I made sure it didn't stick out by examining it from different angles.

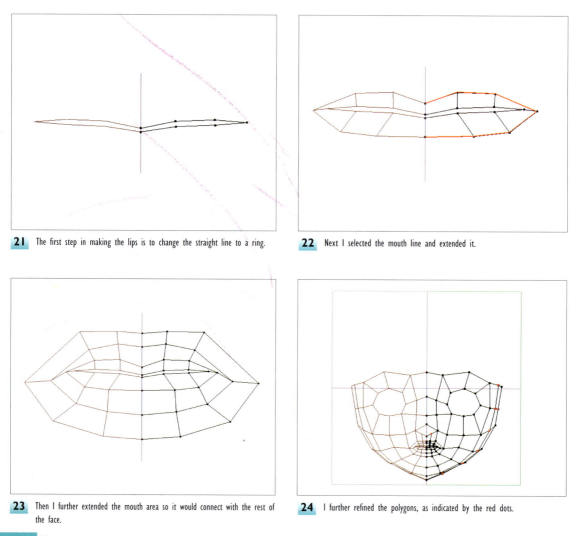

21 The first step in making the lips is to change the straight line to a ring.

22 Next I selected the mouth line and extended it.

23 Then I further extended the mouth area so it would connect with the rest of the face.

24 I further refined the polygons, as indicated by the red dots.

Remember that anime-style eyes are quite big (26).

Then I decided on the size of the pupil. A character tends to look cuter if it has a larger pupil. If there aren't polygon lines where it's convenient, add the lines (27).

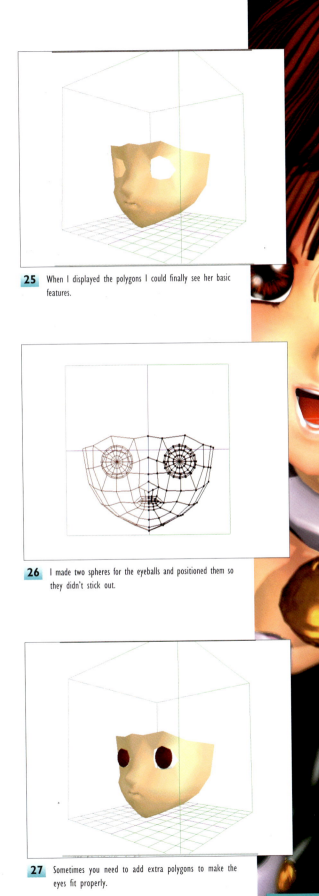

25 When I displayed the polygons I could finally see her basic features.

26 I made two spheres for the eyeballs and positioned them so they didn't stick out.

27 Sometimes you need to add extra polygons to make the eyes fit properly.

Making the lens for the eyeball

In anime you often see stars in the characters' eyes. Those are the lights reflecting off the lenses in their eyes. In order to achieve this effect I made a clear lens on top of the pupil.

First I displayed just the eye. Then I added lines to create an indented border between the pupil and the white of the eye (28). Then I separated the pupil from the white of the eye (29). This displayed just the white of the eye so I could add polygons to this section (30). This area became the pupil, and the cut out section became the lens. I returned the lens back to its original position.

The space between the eyeball and the eyelid is unavoidable. So, this gap must be eliminated. To do this I selected the eye line and extended it inwards (31). Then I displayed the eye and the other parts. I increased the transparency of the lens to show just the pupil (32). The face is completed.

Making the head

First I displayed just the face. I extended the lines of the eyebrows to

28 To give my character sparkly eyes I first created an indented border between the pupil and the white of the eye.

29 Next I removed the pupil from the white of the eye.

30 I added polygons to the "white" of the eye, which became the pupil.

31 I eliminated the gap between the eyeball and the eyelid by selecting the eye and extending this area inwards.

create the forehead (33). Using the same technique I created the top and back of the head. It is important to make the round shape with as few polygons as possible (34). Finally, I extended the lines of the jaw and connected them with the polygons on the back of the head (35).

This completed the rough modeling with HexaSuper. Although the model was rough, it was proportioned correctly. So, if I was only working with HexaSuper, I could have split each polygon to smooth out the surfaces to create a reasonably well-defined face. Back when I only used HexaSuper to model, I used to use around 700 polygons just for the face. It was really tough.

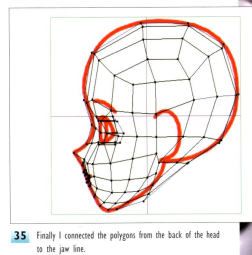

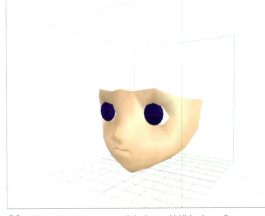

32 I increased the transparency of the lens to highlight the pupil.

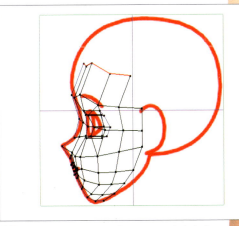

33 I extended the lines of the eyebrows to create the forehead.

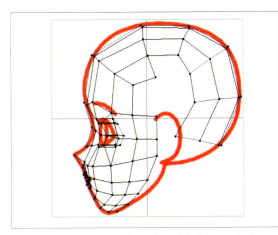

34 Extending the polygons even further, I created the back of the head.

35 Finally I connected the polygons from the back of the head to the jaw line.

Modeling your beautiful girl with LightWave 3D

Now, it was time to use LightWave 3D. HexaSuper can output lwo format files, which makes it simple to import modeling data to LightWave. After I imported these files into LightWave, I applied Metanurbs by pressing the Tab key. Presto! The bumpy face instantly became a smooth face (36). This is great!

At this stage I benefited from all the money I paid for this software. I split the polygons and increased the number of them in the areas where Metanurbs rounded the features too much—especially the eyes and nose. At the same time, I eliminated polygons from the areas where Metanurbs added unwanted polygons.

Metanurbs tends to make the model featureless. So, I sharpened up the details. I added the ears at the same time. Compare the character before and after I applied Metanurbs (37).

Once I get a model I like I freeze it by hitting Ctrl + D. If I save the model before freezing it, I can use that file to create models with different facial expressions later.

The last thing I did is paint the texture. In this example, since I used a surface name, "face," for the entire head, in order to apply a flat map from the front I needed to create an image that covered from the top of the head to the tip of the chin and from the tip of one ear to the other. In order to create well-defined facial features I "unhid" some hidden polygons in the back of the head, and print screened it.

Then I imported the image to Adobe Photoshop to paint the details, using the eyes and the mouth for positioning (38).

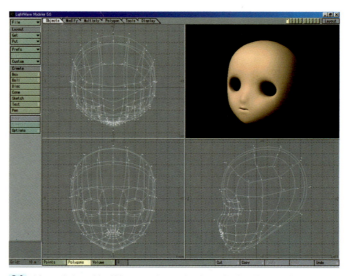

36 I imported the model, which was saved as an lwo format file, into LightWave 3D and applied Metanurbs. The bumpy face instantly became smooth.

How much detail I painted at this stage determined the look of the final figure.

If I had used a single color and painted only the outlines of the eyes, the character would have looked like a figurine. A more detailed map would have made her look less anime like. At this stage I was able to add details that weren't modeled (eyelids, eyelashes and nostrils) to some degree, by painting them on this texture map.

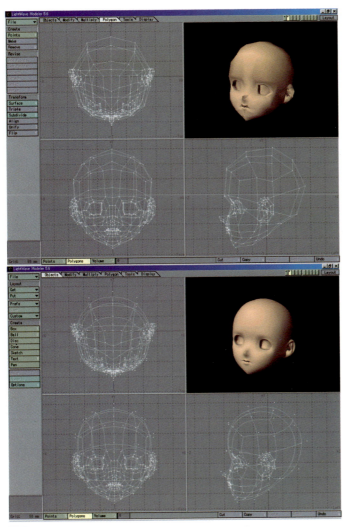

37 Before applying Metanurbs (above); after applying metanurbs (below).

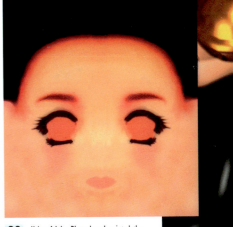

38 Using Adobe Photoshop I painted the facial details, using the eyes and the mouth for positioning.

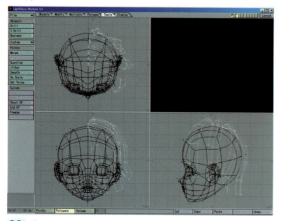

39 First I made a roughly shaped wig and then I separated sections from it.

40 I created 4 different parts for the front and back sections of both the right and the left sides of the head.

41 Before applying the textures I created straight polygons that corresponded with the hair pieces from the 4 parts.

Creating the hair

There are two popularly used methods for modeling hair. One is to model it as one big chunk. This is generally done for figurines. The other is to apply textures onto flat polygons. In this example, I used the latter method. Since applying a texture onto a polygon with a sharp end makes it look like a brush, I used transparent mapping to show all of the separate strands of the hair. Modeling the hair is a lot of work. But because it's the most important element in making a female character, I put much energy into this stage.

I wanted to make a wig in the shape of the hair with bent polygons. So I first called up appropriately sized spline patches with Objects → Custom → LW_Cage, and made a roughly shaped wig to fit the head. Then I took it apart to make something resembling wads of seaweed (39). Although many 3D characters have straight hair, I think that wavy hair makes a character look more 2D.

I used a different surface name for each layer, and overlaid 3 to 4 layers to give the model's hair volume. After I adjusted their positions I used Tools → Custom → LW_Autopatcher to make them into polygons. Since it would have used quite a lot of polygons, I didn't split them too finely.

Using this method, I made 4 parts, one each for the front and back sections of both the right and the left sides of the head. As you can see with all the bright colors, I used many different surfaces (40). The red polygons were the key polygons.

These allowed me to use LWO-CONV, a plug-in developed by Yoichiro Iwasaki.

I made the same number of new straight polygons with the same surface names, and set the key polygons (41). Then I named each part. I like to choose a name that relates to the Morph Target model and the straight polygons. Next I applied the LWO-CONV plug-in. It rearranged the straight polygons so that they matched the Morph Target.

In the layout screen I applied textures on the straight polygons, then I applied Objects → Deformation → Morph Target with the bent polygons as the Morph Target. I set the Morph Amount at 100% so that the textures would appear along the flow of the hair.

Then I prepared three types of texture, one each for Color, Specular and Transparency. Using several different textures for Transparency added variations to the hair and made it look natural. Because I wanted to achieve the look of a 2D illustration, I used black edges and colored it unevenly. These are the textures I used (42).

After completing the model, I realized that for distribution purposes I should have made the hair in one large chunk that doesn't need texture. This way people with different software could see the same thing. Well, my mistake.

42 Here are the textures that I used to create the hair.

Making the body parts

To create this character I recycled a body form that I had made in the past. In order to build the figure without using Bones, I separated the sections of the body at each joint and added semi-spherical joints. The entire body with all the parts looked like this (43).

Making the clothes

In making the tightly fitted upper part of the dress, I used Tools → Sm Scale to enlarge the model of the body and Tools → Drill to cut out the hole. Then I used bump mapping to add the creases (44).

I made the skirt by modifying a spline patch as shown in the figure using Objects → Custom → LW_Cage (45). I tried to give it a flow and placed the creases at uneven intervals to make it look natural. Then I used Tools → Custom → LW_Autopatcher to turn it into polygons to see how it looked and kept adjusting the shape. Because in the example below the

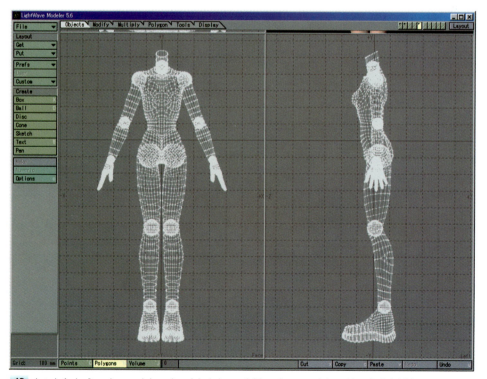

43 Instead of using Bones, I separated the sections of the body at each joint and reconnected them with semi-spherical joints.

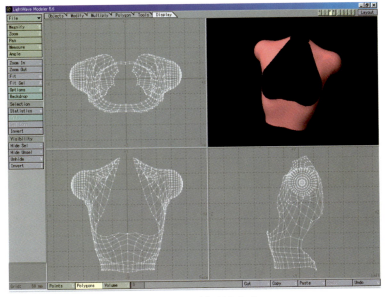

44 I used bump mapping to add the creases to the model's tightly fitted top.

45 I made the skirt by modifying a spline patch.

dress is black it's hard to see the detail but this is how I made the creases (46).

I reused the skirt, turned upside down, to make the balloon-shaped sleeves. This is why working with digital data is so great.

This shows most of the body parts (47). Even the dress has been integrated. I tried to eliminate hidden polygons as much as possible to make the model lighter. I guess it's my nature to make even those parts that no one ever sees.

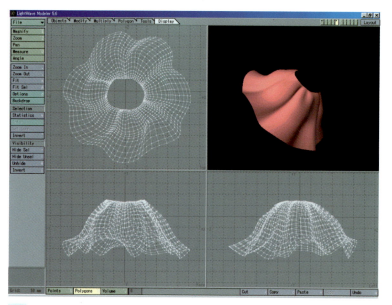

46 Then I added creases to the skirt.

47 I integrated all of the body parts and the model's dress.

I saved the petticoat as a separate part and used Morph Target to give it its lace texture. Once all of the parts were completed I used Polygon → Triple to convert them into triangular polygons. This helps avoid any shadows when they are rendered.

Assembling the parts

At this point I took the model into the Layout screen to give her joints. I used Add → Add Null Object to prepare null objects for each eye, shoulder, arm, wrist, leg, knee and ankle as well as the neck and the base of the head. Then I numerically positioned each part in the center of each ball joint, and made each one a Parent (48).

I used Morph to create all the expressions for the hands and the face. All I had to do was give her a cute pose! My virtual figurine was done (49).

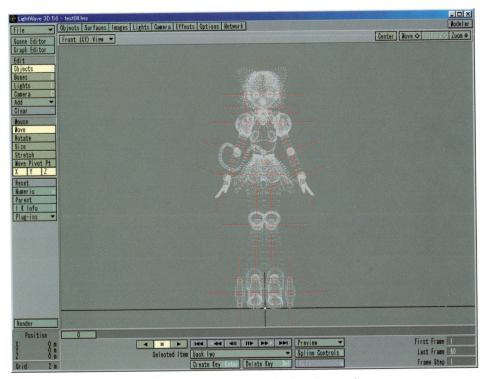

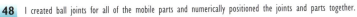

48 I created ball joints for all of the mobile parts and numerically positioned the joints and parts together.

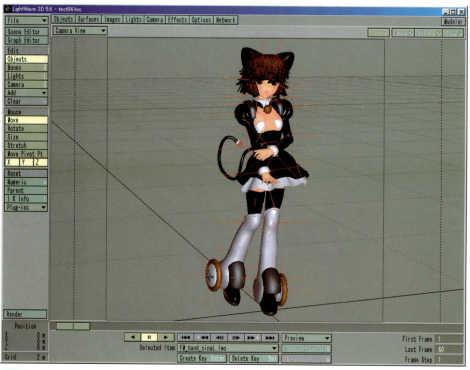

49 Here is my final ReadyMaid.

TIPS: Selecting a 3D software

For the first two years that I was making 3D computer-generated models I used HexaSuper and RayDreamDesigner 4.0J for modeling and rendering. I was making cute girls to show on the Internet. Luckily someone saw them and gave me some work to do. I bought LightWave 3D with the money I got from those jobs.

I chose LightWave because it already had many users and a lot of tips and tricks were readily available. In order to learn how to use software on your own, it is necessary to get information from books, magazines and the Internet.

To tell the truth, I haven't used it for that long. But the modeler is great. Metanurbs is like magic. You could say that I bought LightWave for Metanurbs. Basically, I love modeling. I could do it all day long, but I rarely get them to layout. I'm still studying how to use the Bones function.

Even though I have LightWave now, I still use HexaSuper for rough modeling. On Windows 95 I was using the free version of HexaSuper but it didn't work well with Windows 98. So, I purchased the recently released version of HexaSuper. I think it's plenty good enough for modeling. If you only want to purchase one 3D software, this might be a good choice.

Although LightWave is a great software, it is expensive. If you are a 3D computer graphics beginner and all you want is to create still images as a hobby, you may be able to purchase a less expensive software. The more expensive softwares have increased processing speeds and features such as animation. If all you want is to try out creating 3D computer graphics, you can use the free version of HexaSuper for modeling and a demo version of some 3D softwares to render and print out.

In the end, no matter what tools you use you can create great 3D graphics if you master them. But to do that, you must read the user's manual thoroughly. Videogames are designed so that you can start playing them without reading the user's manual. However, 3D software is not that user friendly. It is a tool for working. You must read the manual. It is true that expensive software lets you create impressive graphics more easily.

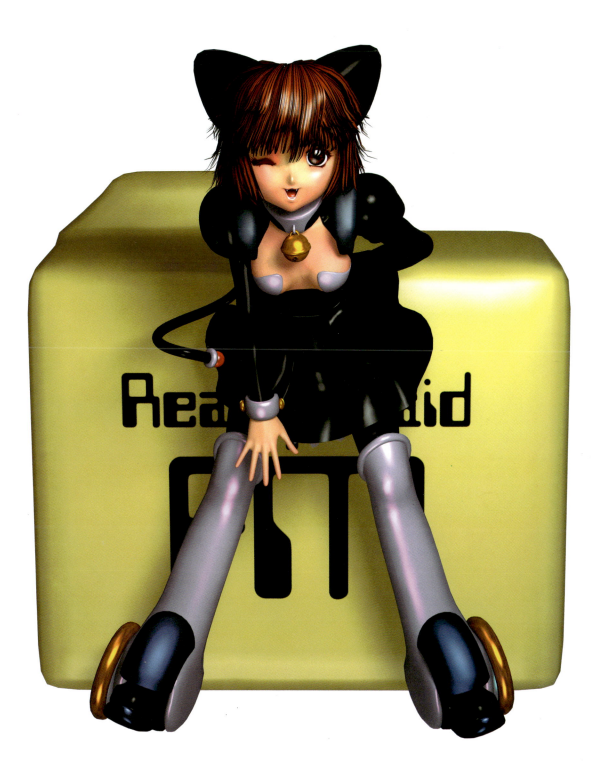

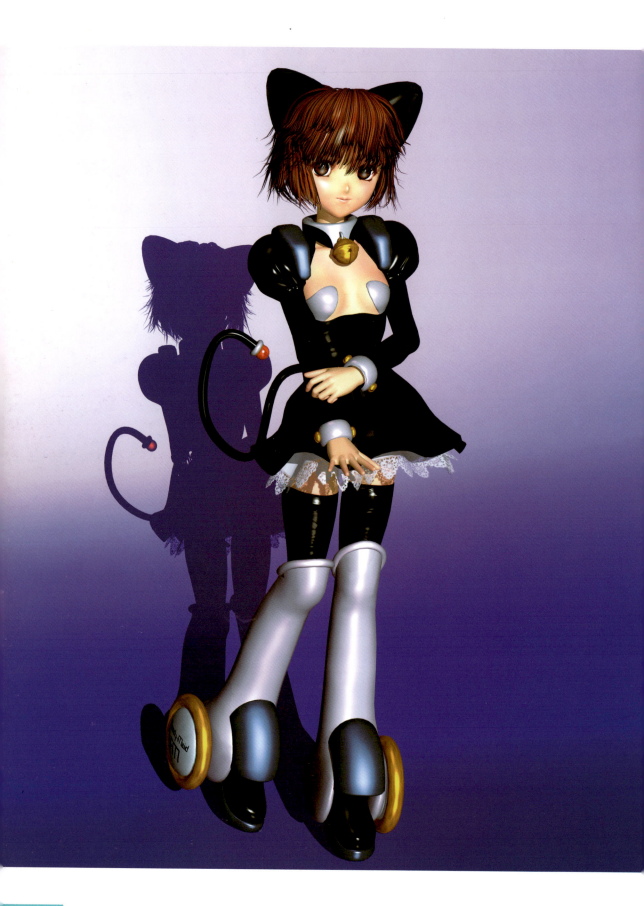

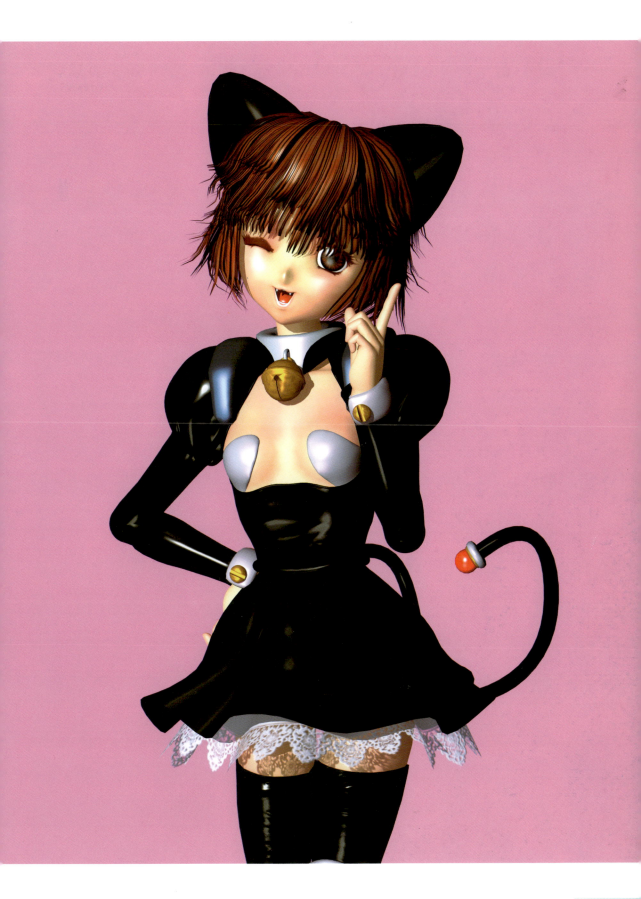

Nekotom

Bringing your anime characters to life

It looks bad to have angular lines around the face, hair, bust and thighs—the places on which people tend to focus. So, you must smooth them out while modeling. If you use a polygon-based modeling software, it's hard to get rid of them completely. If that is the case, you have to correct them with a graphic retouching software, such as Photoshop, after you've rendered the model.

Nekotom

Profile
Born on April 17 in Nagano prefecture, currently live in Tokyo. Udon noodles are my staple food. The lame reason why I started working with 3D computer-generated modeling was because there is no waste. I think I am a serious machinery modeler, but nobody around me agrees.

Working Environment
• Pentium III 500MHz Dual (512MB)
• LightWave 3D 5.6
• Photoshop 4.0.1J

nekotom@mbd.ocn.ne.jp
www.geocities.co.jp/Playtown/5147

璃火紫 きせら
Ripomurasaki
kisera

Why I started creating these beautiful girls

What would you do if, one day, you were taken into a room with just a relatively fast computer and was told that you are going to be a robot and to create just robots forever?

I would say, "Yes! Thank you, God!" That's how much I love robots. But if I were really put in that situation, I would eventually get bored. In fact, I am bored in such situations.

In other words, the "Robot Juice" in my "Robot Glands," somewhere in my body, has dried up.

Just when I needed to refresh my mind, I began making human models to broaden my horizon. I found this work to be unexpectedly fun and before I knew it, I was hooked. That is how I became a modeler of cute girls. (Laugh)

But when the "Girl Juice" in my "Girl Glands," somewhere in my body, dries up, I will probably go on to create other things.

Looking back on how I created the characters featured in this book, I would have liked to have spent more time on the hair. It's not that I cut corners, but I would like the hair to look heavier and have more density. The reason I couldn't do what I wanted was quite simple. The power of the machine I was using for the rendering process just wasn't strong enough. In order to make the outline of the hair smooth, I divided the polygons as small as possible. This resulted in making its data really heavy. As I have decided to use a faster machine next time, I should be able to make something more elaborate.

Considering all the time I spent making the costume frilly, I should have come up with more expressive poses that are suited to the clothes. In order to do that, I would have needed to control all of the parts. Maybe if I had used the Bones function, then I could have posed the model so that the costume and the gestures wouldn't have interfered with each other unnaturally.

Making a catchy character

For this book I wanted to create a really catchy character. After considering my style, what's in fashion and my personal taste, I decided to create a waitress character with a frilly costume. It's so embarrassing to even mention it. By the way, 80% of this decision was based on my preference.

Normally, I would have drawn sketches to visualize the idea at this point. However, I didn't make any sketches, because I decided, for some reason, that I would do the visualization along the way. I later regretted this decision. You should never try this.

Determining the character's background

The next thing I did was create the background settings, such as the name and the profile, in order to define the character's image. However, a big problem arose at this point!

I guess I'm not good at creating a name for a character if she doesn't have any story behind her. I just couldn't come up with anything good. I need to love my work more.

So, in order to move forward, I asked a writer friend of mine, Hamp, to help me develop the character's background. He helped me to come up with a totally abnormal, unique profile. I would have never come up with these ideas on my own. I thank him for this.

Considering other variations

Since I decided to make a character with a uniform, I thought I would create other characters—because characters with uniforms basically use the same body. I could easily create different characters just by swapping the head. Wishful thinking! In the end, this turned out not to be so easy because I had to adjust the object data individually for each character. Such is life.

Since the first character was a heroine type, I wanted the other characters to brighten up the scene. So, I created a cheerful type, one with a pair of glasses and a little kid type.

Making the head

The actual work began. First I created the basic face in LightWave 3D using Metanurbs (01).

I squeezed and pulled this prototype to make different types of faces (02, 03, 04, 05). The major differences in the features of these characters are the eyes. After I created the polygons, I adjusted any unwanted kinks with the Smooth function in Tools. I set the Iteration value to 20 to do this.

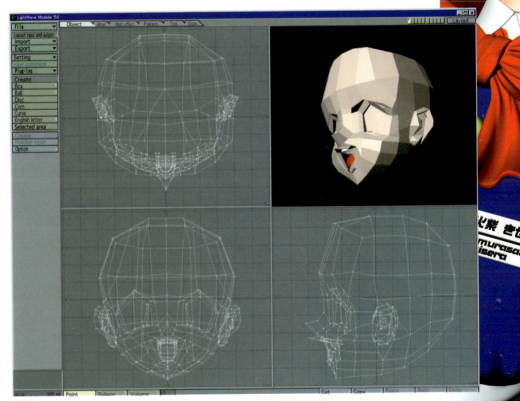

01 This is what my character looked like before I converted it from polygons in LightWave 3D.

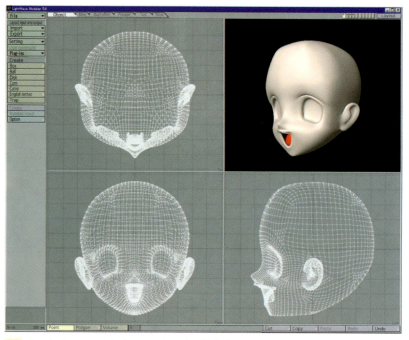

02 My main character was a heroine type so I gave her slightly droopy eyes.

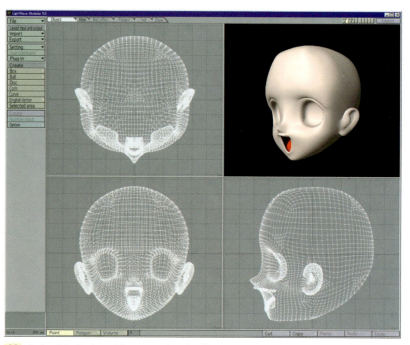

03 I adjusted the droopiness of the eyes to make a cheerful type.

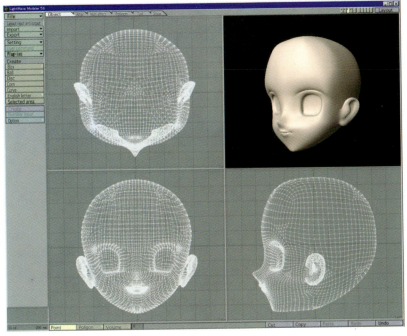

04 Then I adjusted the eyes even more to make a girl with glasses—without glasses.

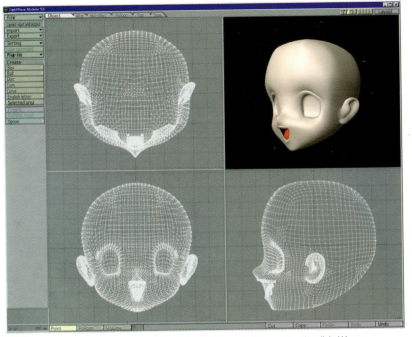

05 By starting with my original prototype and adjusting the lower part of the eyes I made a little kid type.

璃火紫 きせ
Ripomurasa
kisera

06 Highlights are one of the most important factors in creating an anime-style character.

Adding details to the face

Because most people focus their attention on the eyes, I create them relatively large and with much care. For example, changing the size and the position of the highlights alters the expression of the face. Usually highlights just reflect the surrounding lights, but with anime-style characters the highlights are one of the most important factors in creating a character's expressions.

There are rules that some people follow for creating highlights, but I have found that there is no correct answer. So, I try different highlights until I get the expression I want (06).

A lot of the identity of an anime-style character is in the hair. I think the hair is almost as important as the eyes.

So, I decided to do an experiment with the head of the little kid character. I left the head and the top objects untouched, and changed the details of the hair, including the sideburns, and its color. As you can see in the figures, making a few simple alterations changed the look of the character quite a bit (07, 08, 09). Since they turned out so well, I decided to use all of them and call them three sisters. (Laugh)

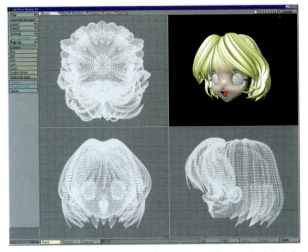

07 I gave the little kid character some hair. Here she looks like a bit of a featherbrain.

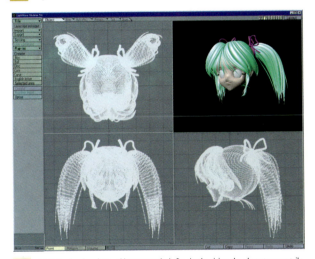

08 I left the head and top objects untouched. By simply giving the character ponytails, I made her look a spoiled kid.

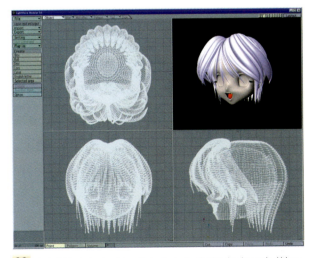

09 Again I left the head and top objects. By simply adjusting the character's sideburns, I made her into a goody-two-shoes type.

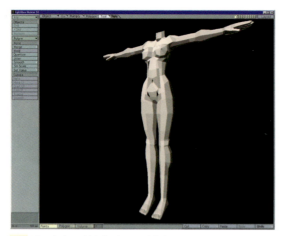

10 Here is the model before I converted it from polygons.

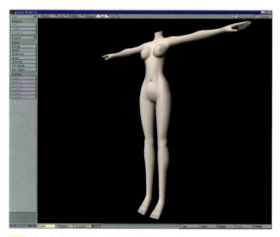

11 Here is the model after I converted it from polygons.

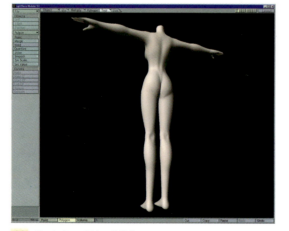

12 Here is the model from behind.

Making the body

As with the head, I made the body with Metanurbs. This allowed me to alter the prototype and create different bodies later (10, 11, 12).

When making any kind of polygon-based model, not only human bodies, it is important to be aware of the polygon edges and the graininess of the textures used. Polygon edges are angular lines around the outline of a model.

It looks bad to have angular lines around the face, hair, bust and thighs—the places on which people tend to focus. So, you must smooth them out while modeling. If you use a polygon-based modeling software, it's hard to get rid of them completely. If that is the case, you have to correct them with a graphic retouching software, such as Photoshop, after you've rendered the model.

Making the costume

The same method that is used to make bodies can be used to create textures. It is not good to have grainy textures on the face and the clothes. While correcting polygon edges is relatively easy, it's much more difficult to correct grainy textures once they are rendered. To avoid this problem, it's necessary to prepare larger textures from the beginning.

Just by taking care of these two potential problems, the final images will look much better. I recommend paying as much attention as your tools and production time will allow on these details.

I began making the embarrassingly frilly costume while still regretting that I had never made any sketches. This is what I made after a lot of struggle. It's just too embarrassing, but I'm satisfied (13, 14).

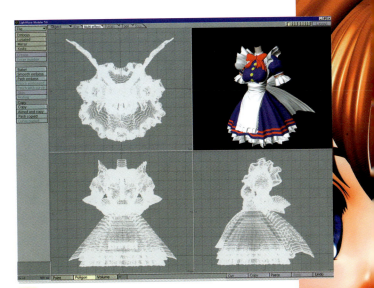

13 The big bow is the key to this character's costume.

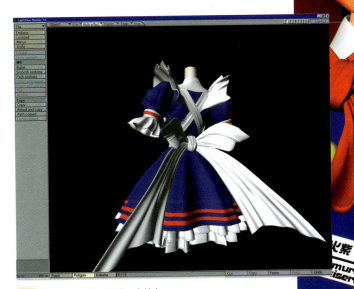

14 The bow looks like this from behind.

Doing the layout work

Since the girls I created this time were anime-style characters, I used only clean and vivid colors and textures. Finally, it was time to take the characters into the layout screen and pose them. I posed each one to match her personality. Because slight changes in the angles of the limbs and head greatly altered the figure's expression and impression, I repeatedly rendered each figure until I achieved what I was looking for (15, 16).

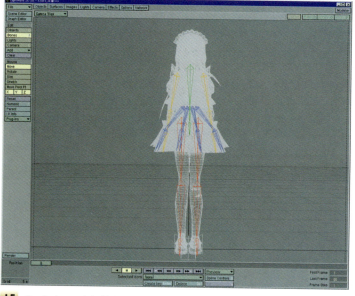

15 The skirt is controlled with Bones.

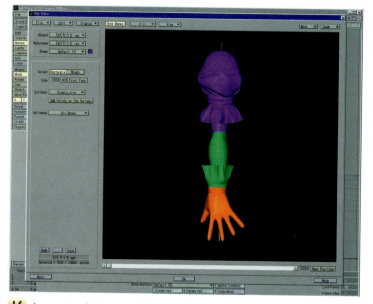

16 I use a commercial plug-in called PGL to control Bones.

Retouching the images with Photoshop

At the very end of this process I took the rendered images into Photoshop to retouch them. I adjusted the Hue and Saturation settings to get vivid, anime-style colors. After retouching all of the images, I placed them in a folder and this job was finished.

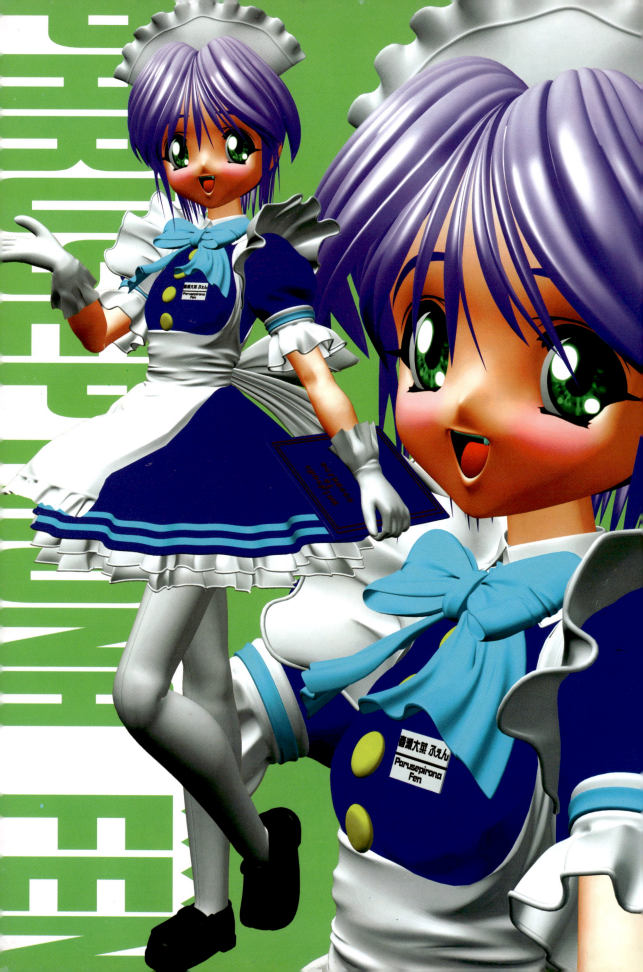

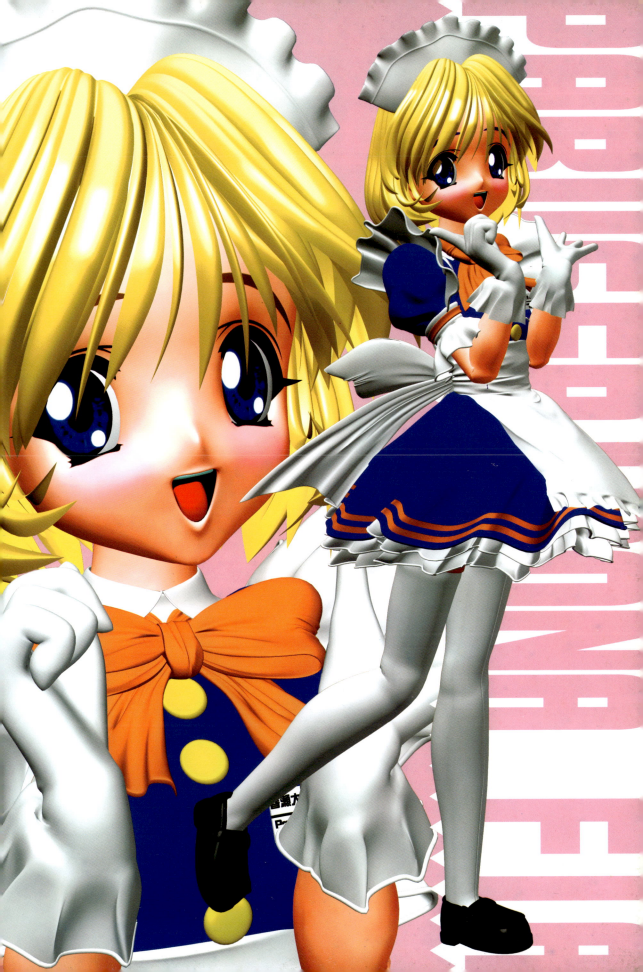

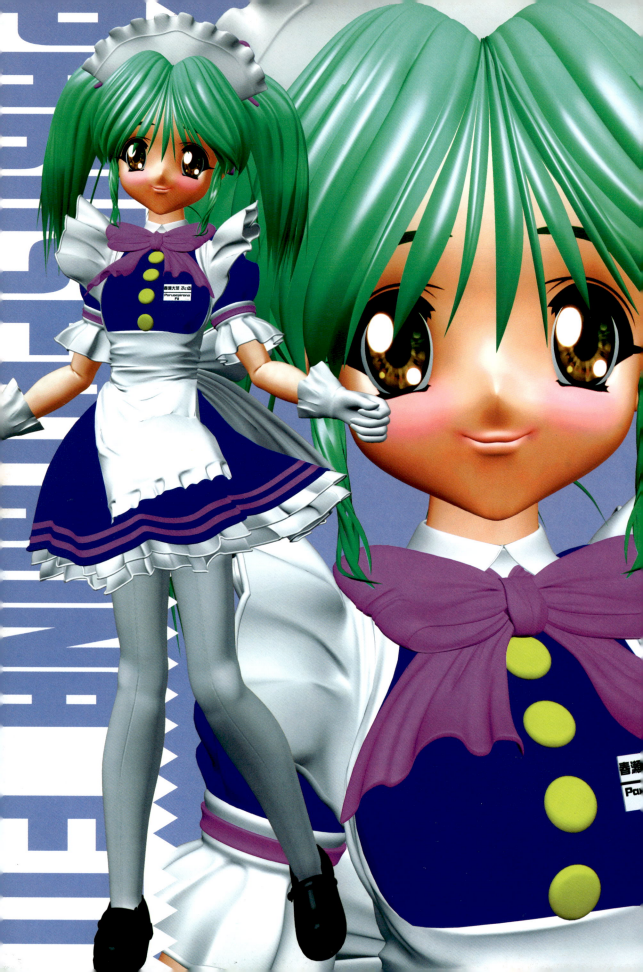

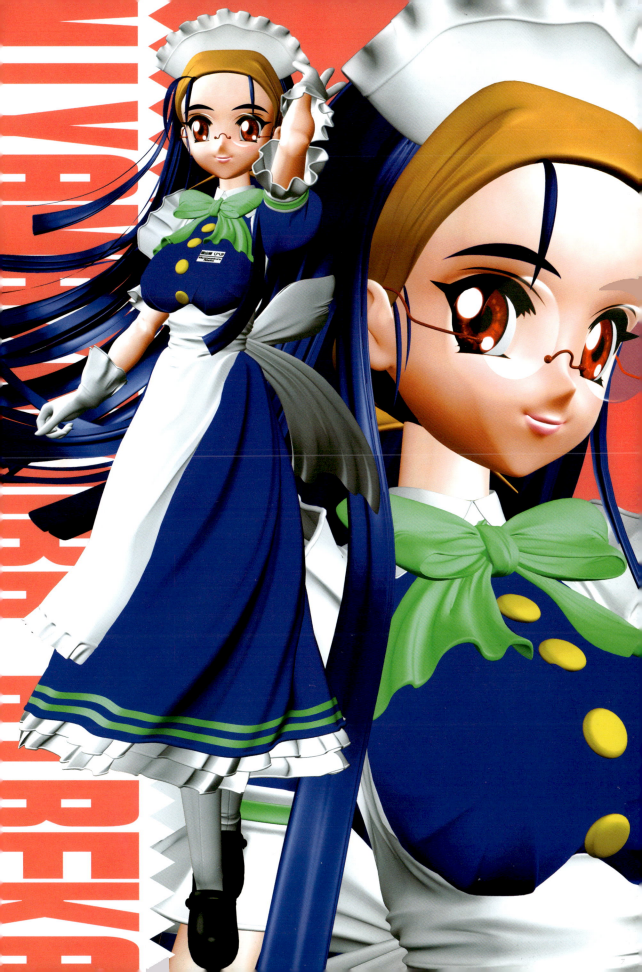

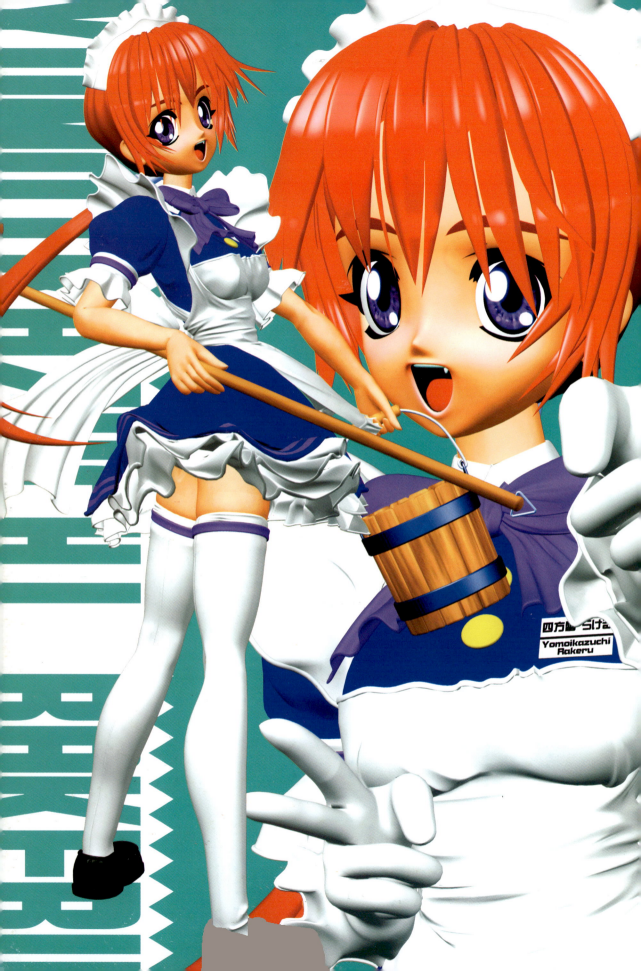

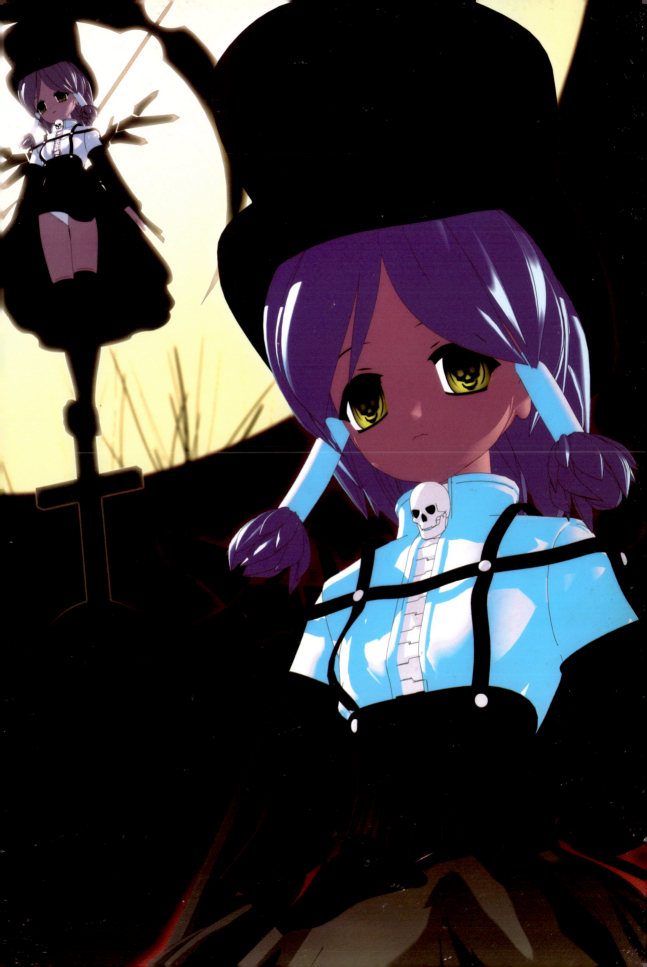

Watanabe, Tetsuya

Creating virtual beauties with the latest technology from LightWave 3D

Software capabilities are getting better and technological limitations are disappearing. Two new plug-ins, developed by Worley Lab, helped my virtual beauties evolve in a leap that ordinarily might have taken five years.

Watanabe, Tetsuya

Profile

After working as an industrial CAD operator, I became a freelance computer graphics artist. I now head the movie circle ANITEMP, which is active in the Chubu area of Japan and my works are submitted to various film events and contests. I have received awards at DOGA 7, 9 and 10, and WavyAward 97 and 98. My most recent works include package design for Dangaio, the TV show Lost Universe and a computer-generated modeling and package design for KSS Danziger 3.

Working Environment
- Amiga 4000/40
- Pentium2 266MHZ DUAL (256MB)
- PowerMacintosh 6100
- LightWave 3D 5.6
- Photoshop 3.0J

nave@anitemp.com
www.anitemp.com

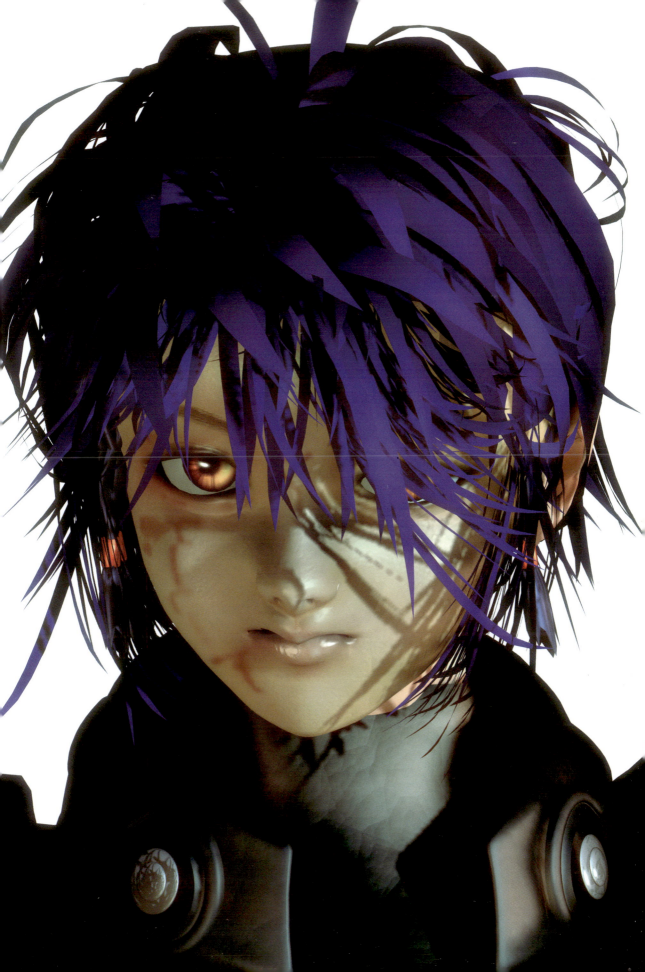

What is "beauty"?

Naturally, for this project the girls have to be "beautiful." People think of many different things when they hear that word. I guess the first element that I consider is the face—especially the eyes and the lips (01).

Nice eyes

The first feature that captures my attention is the eyes. Eyes are very important. Like they say, "the eyes speak just as much as the mouth."

When making virtual beauties, it is important to clear the highlights in the black lens part of the eye. I'm sure you've noticed that in many animes they omit this highlight intentionally—especially when the heroine loses her will and falls under the control of an enemy with supernatural power. Be sure not to create a mindless character.

Wet lips

The next thing I pay attention to is the lips. Well, maybe it's because I just like women's lips. I think wet lips are a requirement for a beautiful girl. In fact, I have no doubt about it!

I always prepare a specular map for the gloss and a bump map for the wrinkles of my characters' lips. With anime characters, I paint the highlights with a color map. When the highlight with the specular map goes nicely onto the lower lip, I think it looks really sexy.

Balanced face

The third component I focus on is the balance of the facial elements. The basic rule is to make the outline of the face an inverted triangle—the eyes large with large pupils, and the nose and mouth small. In other words, it is the face of an infant. There is a theory about why the infants of all animals look so cute. They say that if their parents die, another adult might raise the infant. Being cute is a weapon of survival.

Naturally, this characteristic is very noticeable. This is especially prominent with my characters that have recently become popular.

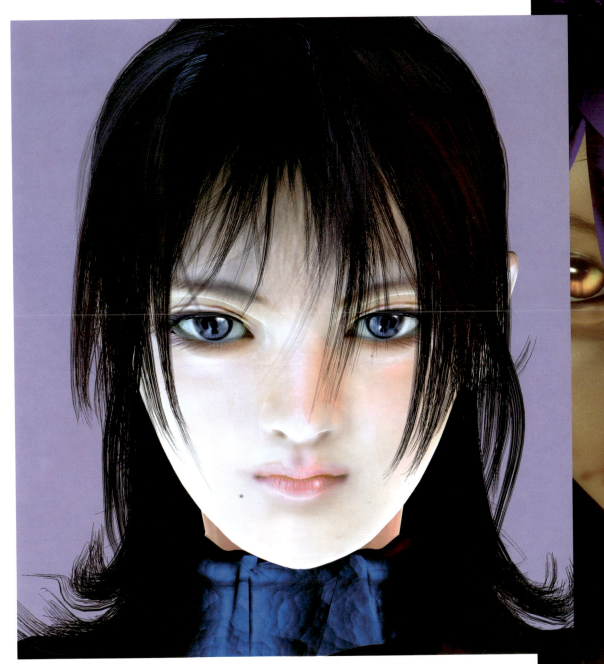

01 This character has all the key features of a virtual beauty—nice eyes, wet lips, a balanced face and realistic hair.

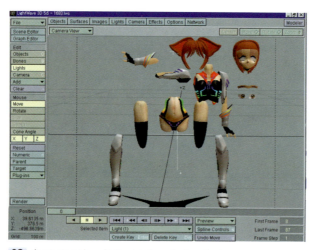

02 As you can see here with Nao, I don't use the Bones function.

03 I find it easier to move my characters if I don't use Bones.

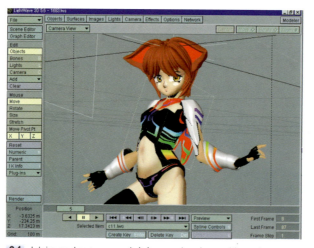

04 I design my characters so you don't focus on where the parts join together.

Body

I think that 80% of the modeling is completed once the head is done. If I were making a still image, I could add some trims to the face and call it a work of art. However, since I'm not interested in creating works of art, I always make a body to go with the head.

The trick is to make sure that I have the correct dimensions of all of the parts and that their balance is right. If I get these things right, the actual modeling doesn't have to be perfect. Once the character is animated, you can get away with a lot of things.

When I'm building a character, the only thing I do differently from other creators is that I don't use the Bones function (02). The reason for that is because I just don't like using it. (Laugh)

Every software is different, but with LightWave 3D, the software I use, working with Bones makes the model heavy and hard to pose. Plus it is hard to control her expression (03). Because I'm so impatient, I hate anything that's heavy or slow, yet at the same time I'm generous enough to allow a few bad-looking joints. (Laugh)

Most of my models are built with simple, hierarchical construction. Hal and Nao are no exception. I'm sure many of you may not agree with me on this point, but I believe a character that can move freely but has some bad-looking joints is much more charming than one that doesn't move but has clean-looking joints. Besides, when I'm creating a movie I usually have so many other problems that I can't concern myself with small details like bad-looking joints.

In other words, it's not that I don't mind a few ugly joints, but rather I don't have time to worry about them. Having said that, it is better if you can hide those ugly joints (04).

I always put a mechanical-looking suit on my model to hide the joints. Since I am both the designer and the director, all I have to do is come up with a design that hides all the flaws.

Once in a while I combine IKs to make "easy automatic Bones," but this time I didn't do that. I guess you could call Nao a "zero Bones" humanoid model. (Laugh)

The only drawback with this method is that I can't create a shower scene, because I can't hide the flaws if the character is naked. (Laugh)

Dynamic hair

I always agonize over the hair (05). Although there is a famous morphing technique that makes hair realistic, I find that using transparency maps is too heavy and allows only limited freedom with the hairstyles. There are many problems.

After contemplating different methods, I decided to use object pieces when I created Hal and a large block when I created Nao. Although, I like them both, a friend asked me if I copied Sonehati's technique (see http://home.interlink.or.jp/~polygons/) to make Hal's hair (06). Of course, not! Sonehati uses texture mapping, but I don't. Wait a minute, that's no good.

Texture

This is one of the areas I put some effort into. Then again, I don't paint

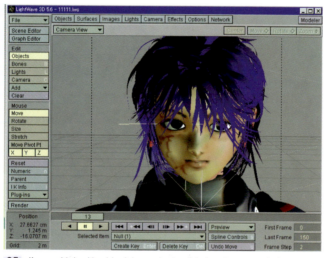

05 If you model the girl and her hair properly, she will look good—even on the layout screen.

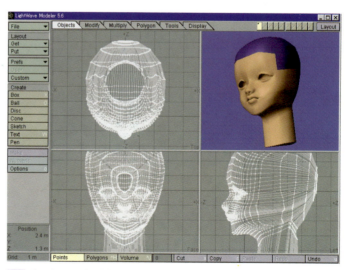

06 An early stage of modeling Hal—before I started making her hair.

many textures, because I don't like to. (Laugh) Instead, I spend more time on the basic settings. What is the material? Metal? Plastic? Cloth? Leather? You can get realistic results if you properly think through everything in advance before deciding on the color and the luster (07). It's helpful to study things around you all the time.

There is one more thing that I consider important. Let's say there is an actual product, and there is a blueprint for that product. Is the computer-generated, exactly-to-the-blueprint model of the product identical to the actual product? No. The actual product might be warped by heat during manufacturing. It might be dirty. In any case, it's not exact to the blueprint.

Humans are less exact than manufactured items. Even the most incredibly beautiful girl has all sorts of flaws. Compared to humans, computer-generated models are too flawless, in my opinion. I believe it is better to be a little rough—you might think it's too rough—rather than to be overly detailed.

When you look closely at a very realistic oil painting, you see dynamic brush strokes. Fortunately, I'm not that exact of a person. Even if I work carefully, things come out a bit warped. But it's no problem because I really don't mind. More serious and precise people should take my lead and start making less exact characters with slightly warped textures. (Laugh)

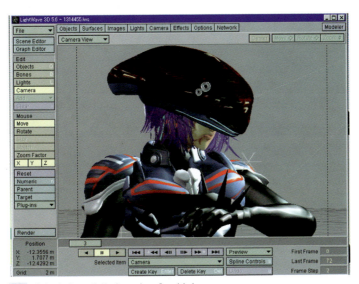

07 Notice the luster of this character's outfit and body.

Light and shadows

Often when you change the lighting of a computer-generated character she turns into a monster. My characters are no exception. If I don't pay close attention, even a girl who is cute one minute can change her looks the next minute to scare my pants off. I have to try such techniques as using strong lights or increasing the luminosity and decreasing the defuse to deal with this.

In other words, I white out her flesh tones. Everyone has been fooled by this technique—which is used on packages of porno videos. (Laugh) However, because this technique has its problems—like some shadows don't come out right and interfere with other characters and objects—it could create a big headache if you're making a movie.

In order to avoid this headache, I made my character wear a helmet. This way I didn't have to worry about the lights or whether her hair, eyes, and lips were in sync while she was fighting. And it gave her a new characteristic. What a deal! I'm patting myself on the back.

Adding a soul

After I complete the modeling stage, I have an additional step that I call "putting a soul" into the character. It sounds really cool—like something a master craftsman would do. All I do is make the final adjustments to the model. The actual steps include:

(1) I don't do anything. I let her sit for half a day or more. When you're looking at only one thing for a long time, you lose a sense for what is good and what is bad. Unless the schedule is really tight, I don't look at the model for at least half a day after I finish her. This allows me to initialize my brain so I can look at my work objectively.

(2) I play with the model as much as possible.

(3) I render her over and over. This allows me to find any flaws and see angles from which the model looks bad.

(4) I doodle. I doodle on rendered images with the Paint tool. I think drawing by hand makes these images come alive. I study how to make my characters come alive.

(5) The last thing I do is adjust the textures and the model.

The trick here is to forget that you have created the model and to forget that it's you who is making these corrections.

Looking for flaws in your own work is an unpleasant job. Being as objective as you can possibly be is the secret to success (08).

The original illustration of Esprit.

Using the latest technology from LightWave 3D to create virtual beauties

I created Hal and Nao with LightWave 3D, version 5.6. Various notable improvements have been made to the program since then. I will explain some crucial points that are applicable to creating virtual beauties with this new version—7.5.

Improvements in LightWave 3D

I've been using LightWave since version 3.0 and this new version is the first time ever that the developers have introduced such major changes. Although some small problems have surfaced, the overall improvement is really significant.

The major difference is that you can now do spline rendering (09). As a result, your characters are made from fewer polygons. This makes it much easier to handle, control and manage the files (10).

The next improvement is that the layers are now able to carry a model. So one LightWave file is able to hold multiple models on each layer. This makes it much easier to make a single LightWave file, even a file that holds multiple models with a complicated hierarchy. So, when you are creating your virtual beauties, you can contain all the elements—such as hair, clothing and accessories—in a single model. Overall, you should see a big improvement in managing your files.

Improvements in the Bones function

Finally, with version 7.5, LightWave's Bones function has become good enough for me to use. I expect to use Bones much more often than I used to during the overall processes—and even on projects now in progress. I am finally able

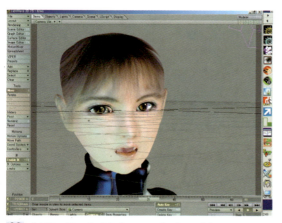

09 LightWave 3D version 7.5 allows you to do spline rendering.

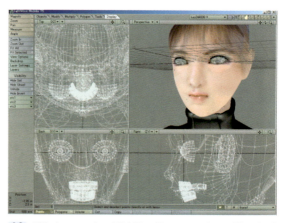

10 With the new version of LightWave 3D you save polygons. This makes it much easier to handle, control and manage the files.

to enclose as many bones as I want in my characters. With this latest version, the Bones function is much improved and easier to utilize. You can use it as you used to, except that now, at last, you can create more useful bone models.

The major difference is that you can adjust the effect range on both polygons and points. So you can create characters with the least amount of bones without needing to create sub-bones to support the forms you want to make. Managing files is now easier, but the processing speed is slower due to the weight map for each bone. Still, the overall performance of this version is significantly improved, so that taking more time on the bone structure could be acceptable. You can place the effect range on each surface and point on a weight map you made in the Modeler function.

After that, the basic operation for finding the best points is to define the weight map for each bone, then to make adjustments back and forth between the Modeler and Layout functions (11). It used to be possible to make bones in Layout but now, laid-out temporary bones, called "skelegons" in Modeler, are switched to bones in Layout. This feature enhances the process of placing bones, and it makes the adjustment of the weight maps easier to see in Modeler.

The skelegons created in Modeler can easily become bone (12). The new function is equipped to display frontal bones just like X-rays. You can even display the effect range of bones in different colors to make them easy to recognize (13).

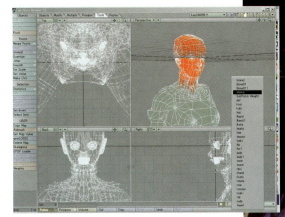

11 The basic operation for finding the best points is to define the weight map for each bone.

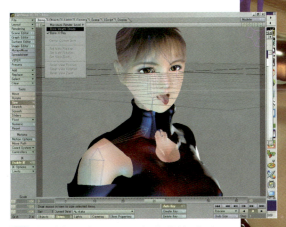

12 The skelegons that you create in the Modeler function become bone once you switch to Layout.

13 Bones can be color-coded to make them easier to identify.

Improvements in the morphing system

Conventionally, when you wanted to morph your character, it was necessary to prepare another model. Morph Targets are now able to be memorized as mapping data, with point numbers different from the base model, which can then be mounted to LightWave.

Also, with the displacement plug-in Morph Mixer, you are able to preview multiple Morph maps (14). One advantage of this is that you don't need to let LightWave read the Morph target scenes that aren't necessary for rendering. Another advantage is that you can control them visually and instinctively. This gives you more control over the expression details and makes management much simpler (15). The most important thing is that this process has become so much fun. (I really believe having fun is important and keeps you motivated to continue working—particularly in the process of 3D character making. Don't you agree?) It's fun! Isn't it? (Laugh) (16)

New plug-ins

Software capabilities are getting better and technological limitations are disappearing. Two new plug-ins, developed by Worley Lab, helped my virtual beauties evolve in a leap that ordinarily might have taken five years. I recommend both—Sasquatch and Gaffer—to help you experience what I call a "five year evolution" as well.

Sasquatch is ideal for developing your characters' hair and fur. This plug-in is a super tool that creates fabulous

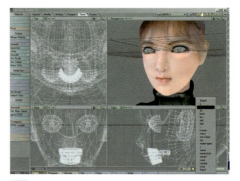

14 The displacement plug-in Morph Mixer allows you to preview multiple Morph maps.

15 Changes to the morphing system have made it easier to control the details of the facial expressions.

16 Morphing your characters should be fun!

17 When in the Layout function of LightWave, apply the plug-in Sasquatch to create fabulous hair effects.

18 The pixel filter plug-in Sasquatch is fairly easy to use—though it can create a wide range of expressions.

19 The new version of the plug-in Gaffer allows you to preview your character's face and adjust the skin texture.

results on hair, with ultimate quality, ease of handling and speed in rendering. I believe Sasquatch is a must-have item if you are serious about creating virtual beauties. Although a light version is available, I recommend you get the full version—as I expect you want to create the best beauties.

To use Sasquatch, first create a line polygon in Modeler as usual with LightWave. Keep in mind that with Sasquatch you create line polygons individually with their surface name. (This was previously not so important.) Apply Sasquatch as a displacement plug-in on the object of gage in Layout (17). Precisely adjust the items—such as texture, degree of curling, etc. The model is still set as a gage, which makes

it invisible at renderings that are made with the pixel filter. Apply Sasquatch's pixel filter plug-in and adjust the shadow set-ups and the rendering quality (18). Although the basic operation is very simple, precise controls could be defined at various points. So, a wide range of usage is possible—including the expression of long hair and fur.

The second plug-in that I use is the new version of Gaffer, which has received great reviews from many artists. The main feature of this new version is that the parameters for the specific usage of human skin were installed. So the plug-in can apply textures that used to be impossible with LightWave alone. In addition, it is wonderful to be able to preview the character's face and adjust the skin texture (19). Even if you are satisfied with the present version, you might consider upgrading, as this preview function makes changes in the basic texture control set up and allows you to achieve the best conditions without a big hassle. Plus, as with the former version of Gaffer, creating metal surfaces is no problem. You can even use the latest SSS technology with it.

It takes some effort to master the techniques for these two plug-ins. Unfortunately, once you get past that, these plug-ins don't come with the next requirement—the taste of a skilled beautician and the sensitivity of a professional make-up artist. So, depending on where your existing beautician and make-up skills are, the plug-ins alone may not deliver a full five-year evolution. (Laugh)

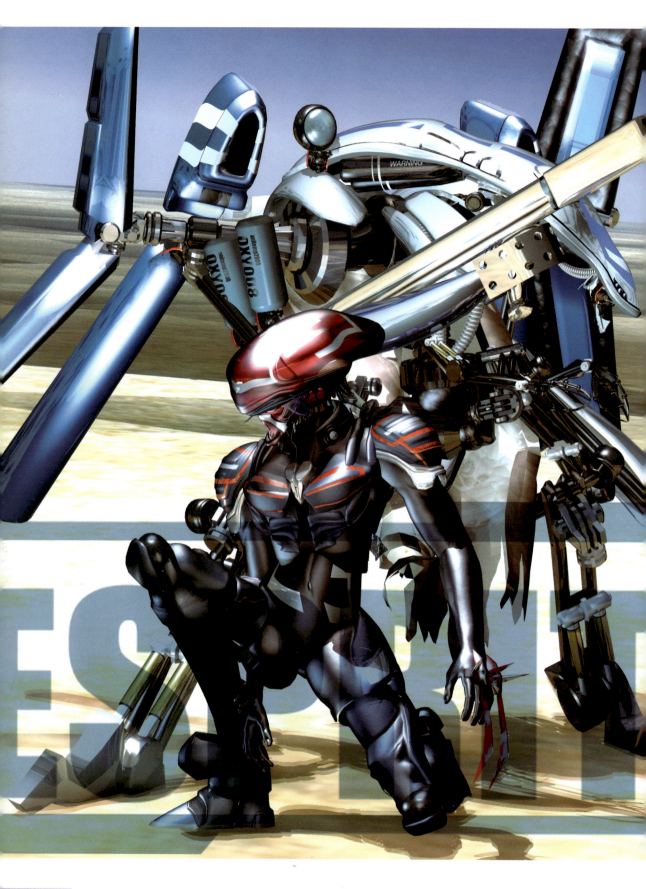

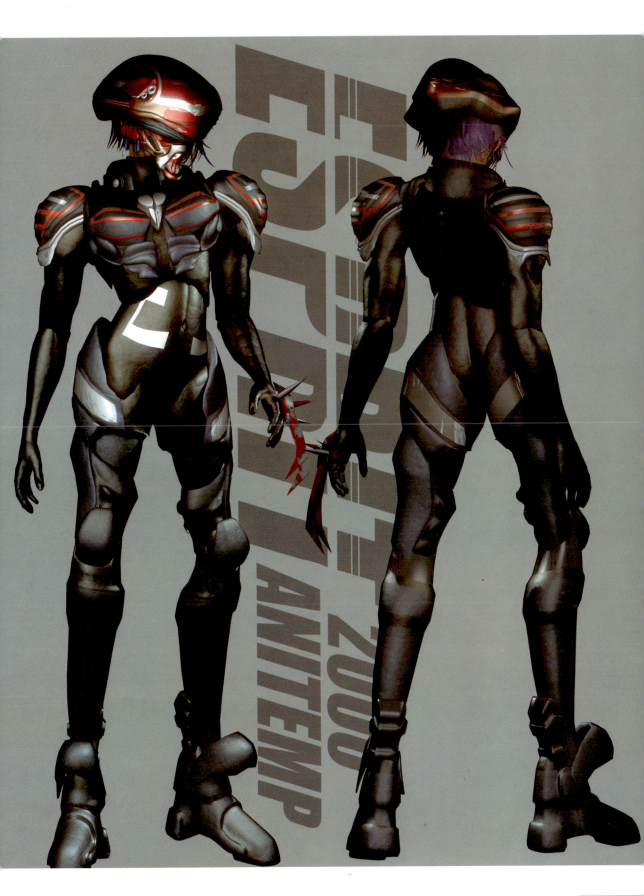

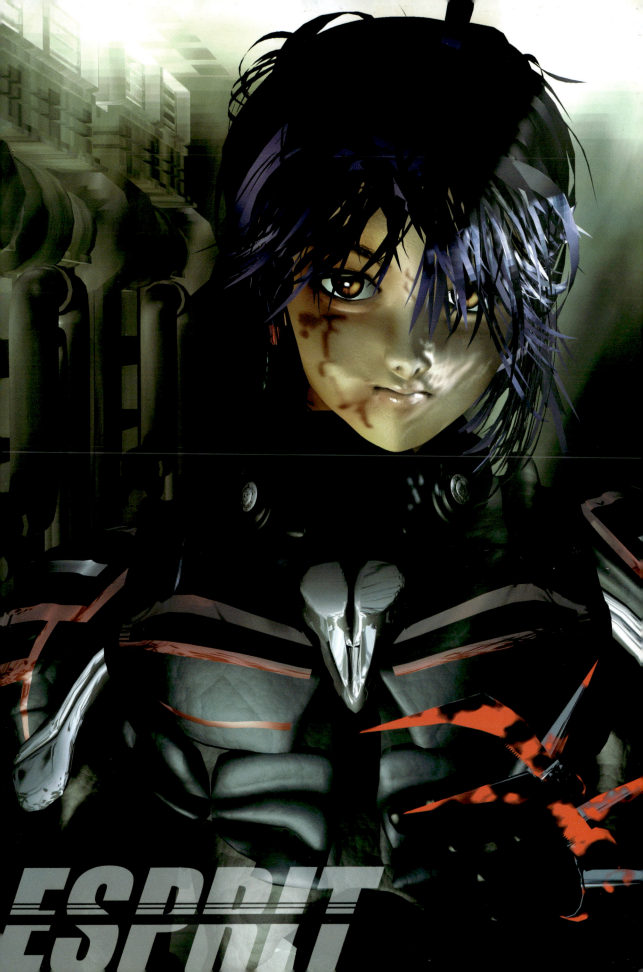

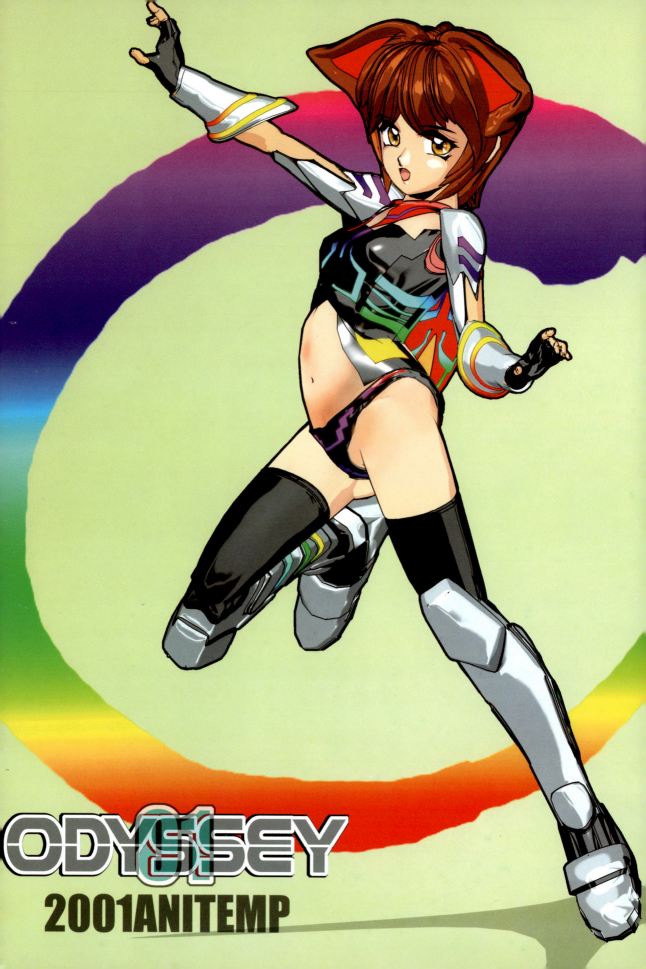

ODYSSEY 01
2001ANITEMP

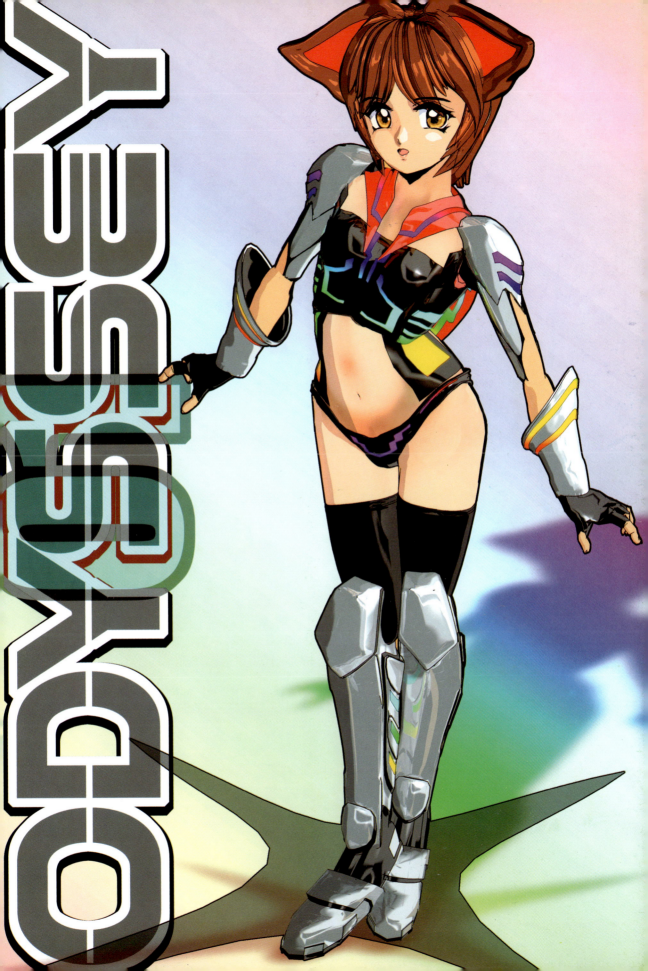

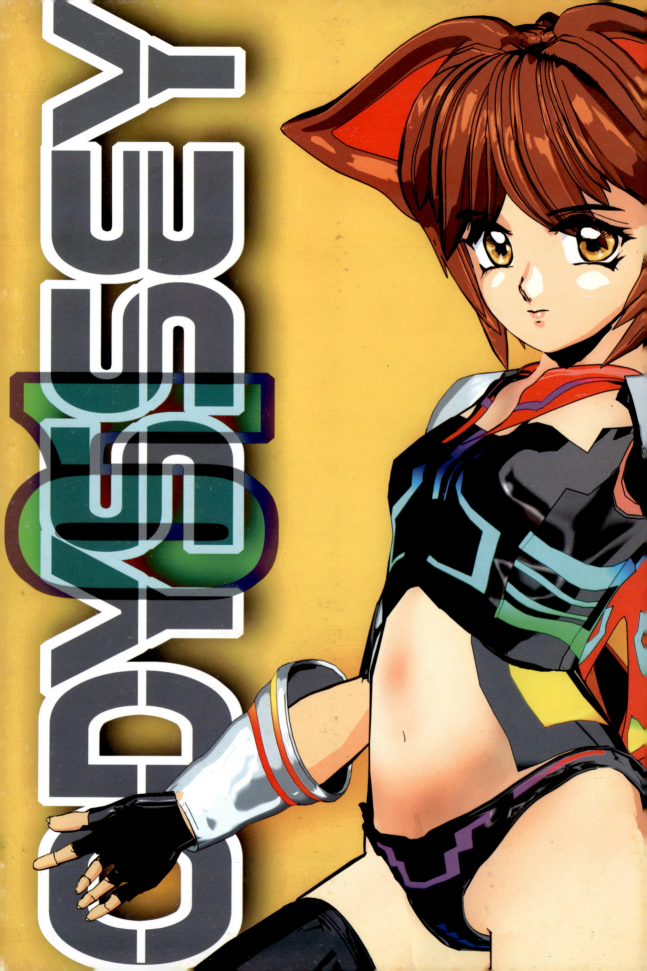

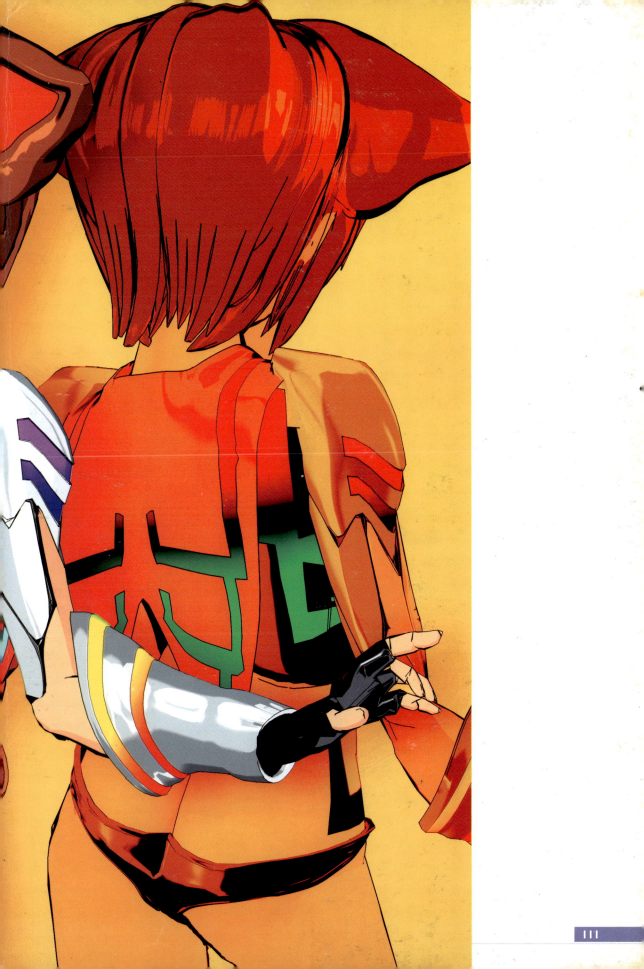

INDEX